THE ESSENTIAL™

Jackson Pollock

BY JUSTIN SPRING

THE WONDERLAND
PRESS

Harry N. Abrams, Inc., Publishers

THE WONDERLAND PRESS

The Essential™ is a trademark
of The Wonderland Press, New York
The Essential™ series has been created by The Wonderland Press

Creative consulting by Platinum Design, Inc.
Design by DesignSpeak, NYC

Library of Congress Catalog Card Number: 98-71936
ISBN 0-8362-6997-7 (Andrews McMeel)
ISBN 0-8109-5809-0 (Harry N. Abrams, Inc.)

Distributed by Andrews McMeel Publishing
Kansas City, Missouri 64111-7701

Unless caption notes otherwise, works are oil on canvas

Printed in Hong Kong

Harry N. Abrams, Inc.
100 Fifth Avenue
New York, NY 10011
www.abramsbooks.com

Contents

The **myth** surrounding the **man** .. 5

The **early** Jackson Pollock .. 12

His Western **childhood** .. 13

The raucous **teenage years** .. 19

His move to **New York** ... 24

Pollock's **idols** and **therapists** 27

Personal **problems** ... 30

Enter **Lee Krasner,** artist then wife 42

Hello **Peggy Guggenheim,** dealer and patron 46

The **myth** begins .. 51

Lee and Jackson move to the **Hamptons** 57

Betty Parsons takes on Pollock 60

Drip painting is born ... 61

Special: Titles of Pollock's paintings—and museum labels 62

Abstract Expressionism enters the vocabulary of art 78

Fame paralyzes the man, brings on the **booze** 84

Willem de Kooning and Jackson Pollock 87

After the Drip, the **Pour** .. 92

Then, **Black and White** .. 94

The blues: Pollock leaves Parsons for **Sidney Janis** 99

Finally, **color returns,** just as all goes black 103

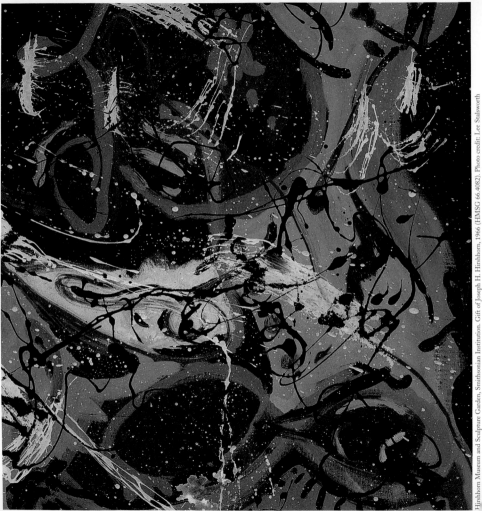

What's so great about Jackson Pollock?

If you can understand Jackson Pollock—and it isn't hard—then you can understand **Abstract Expressionism** and, by extension, everything that's developed out of that art movement—which is to say, a whole lot of what's happened in American art in the past fifty years.

This book isn't just about Pollock. It will also give you the essentials of the movement known as Abstract Expressionism, so that you will understand both Pollock and the art of his time. It's a quick primer in:

THE MAN

THE MYTH

THE MOVEMENT

THE ART

And it's also a lot cheaper and quicker than grad school. So—ready? Here goes.

The Essential Jackson Pollock

Jackson Pollock (1912–1956) is probably the most famous American artist of the 20th century. But don't just take our word for it. Here's what other people have said about him:

- "A shock trooper of modern painting…The heavyweight of Abstract Expressionism" —*Time* Magazine

- "The best painter of a whole generation" —*Clement Greenberg, art critic*

- "A hero" —*David Smith, sculptor*

- "A man seldom at peace" —*Life* Magazine

- "A genius" —*B. H. Friedman, biographer*

The nouns describing Pollock through the years have included **fighter, hero, cowboy,** and **rebel.** Adjectives? Try **violent, savage, romantic, undisciplined,** and **explosive.** Pretty amazing language for a guy who did nothing but paint. So…where did these words come from? What made him so popular, so important in the public imagination? In other words, *"What's the big deal about Jackson Pollock?"*

ABOVE
Self-Portrait
c. 1930–33
Oil on
gesso ground
on canvas,
mounted on
composition board
7 ¼ x 5 ¼"
(18.4 x 13.3 cm)

Collection L. S. Pollock, New York.
Giraudon/Art Resource, NY

OPPOSITE
Jackson Pollock
at age 16

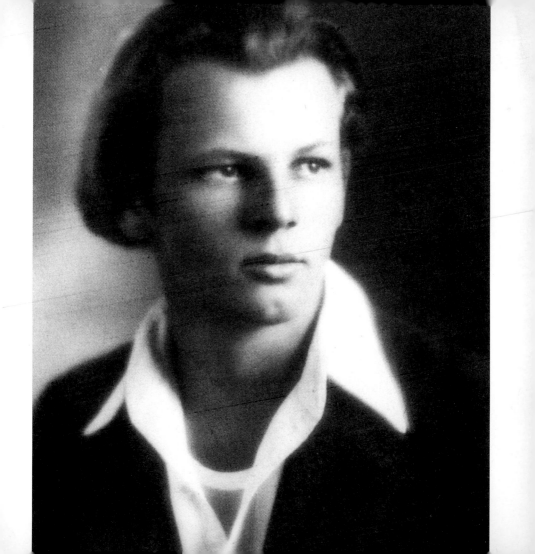

**BACKTRACK:
EXISTENTIALISM**

Existentialism:
The belief that humans
are free to choose their
own actions, and that
these acts determine
one's identity. In existen-
tial philosophy, according
to its leading champion,
the French philosopher
Jean-Paul Sartre
(1905–1980), "A human
is no more than a series
of undertakings" and the
choices, decisions, and
acts made by that
individual eventually
define the meaning of his
or her life. In the late
1940s, Existentialism was
to "thinking" as "the
little black dress" was to
"fashion." Indispensible.
Chic. An absolute must
at any social occasion
attended by artists
or intellectuals.

The Artist as Superstar

The answer, in part, comes from a highly innovative idea that evolved with Pollock: namely, that an artist is a great and important figure in contemporary culture, a sort of genius who embodies the spirit of the times—and whose life is therefore worthy of celebration.

Pollock himself asserted that his work was all-consuming, a kind of **spiritual quest or near-impossible psychic challenge requiring superhuman strength.** To stand before the blank canvas and somehow create meaning and order out of paint was, for Pollock, a manifestation of the existential crisis of modern humanity. In his own mind, Pollock was an Existential Superhero, a man who approached the canvas with a macho swagger—and he made sure people knew about it! Pollock's belief in the importance of the Artist as a larger-than-life cultural icon eventually defined the attitude of an entire generation of artists living in post-World War II New York and has continued to influence the American art scene up to the present day. The enigma of his life and of his intensely private existentialist drama became, in fact, the major subject of his painting. In this sense, Pollock was the first art-world **superstar.**

Flame. c. 1934–38
Oil on canvas mounted on
composition board
20 ½ x 30" (51.1 x 76.2 cm)

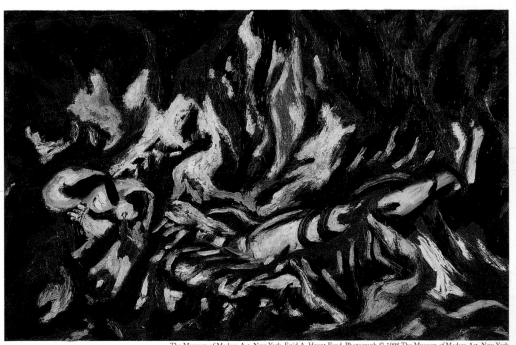

Stenographic Figure
1942. Oil on linen
40 x 56" (101.6 x 142.2 cm)

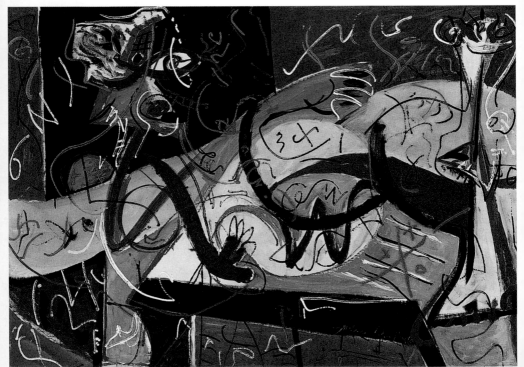

Why was it important to be Existential in Art?

In brief: Assume that art expresses the main spiritual, emotional, and intellectual issues of the day. The mass destruction caused by World War II had focused people's thoughts on death and dying, violence and chaos, and on the uncertainty about the direction in which postwar civilization was headed. So many lives had been destroyed by the war—and for what?

Existentialism gave people a new way to think about the weighty issues of humankind's purpose (or lack thereof) at a time when more conventional ways of understanding life—including religion—seemed to offer few answers.

In Pollock's prime years (1943–1953), the big questions being asked by intellectuals included:

- *What is the meaning of life?*

- *If there is no certain or objective meaning, how do we find or create meaning that is relevant to us?*

- *What is going on inside our minds?*

- *How can we express or share with others what is going on inside our minds?*

BACKTRACK: ABSTRACT EXPRESSIONISM

As the artists of postwar New York grappled with existential ideas, a new style of painting began to evolve which expressed these preoccupations. Characterized by abstract imagery, loose brushwork, and large, dramatic "gestures," the new style was thought to represent some crucial psychic drama depicting subjective emotions rather than objective reality. The new style soon became known by several different names, including Painterly Abstraction and Action Painting, but today it is best known as **Abstract Expressionism,** sometimes shortened to AbEx.

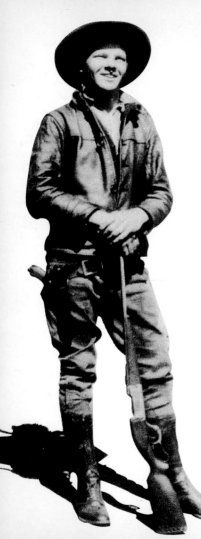

The different Art Forms that asked these Questions

Abstract Expressionism was only one of many movements or art forms seeking to find meaning in the void of everyday existence. Here are some of the others:

- **METHOD ACTING** (Lee Strasberg and the Actors Studio; Marlon Brando, James Dean)

- **BEAT POETRY** (Jack Kerouac, Allen Ginsberg)

- **STREAM OF CONSCIOUSNESS WRITING** (William Faulkner's *The Sound and the Fury*)

- **THEATER OF THE ABSURD** (Samuel Beckett's *Waiting for Godot*)

- **JAZZ** (Charlie "Bird" Parker)

The Making of an Abstract Expressionist

The legend that surrounded Pollock as an adult was forged in the crucible of a **difficult and alienated childhood and adolescence.** The key to his **restless character,** and to some extent to his art, can be found in his early years, a time of great transience and instability.

An Off-Balance Childhood

Paul Jackson Pollock (he discarded the first name in 1930, when he arrived in New York) was born January 28, 1912 into a Scottish-Irish working-class family in Cody, Wyoming, where his strong-willed mother was a seamstress and his father was variously a farmer, sheep rancher, and stone mason.

- Pollock's mother, **Stella May McClure Pollock** (1875–1958), was difficult, controlling, and ambitious. In later life, Pollock would come to view her, in terms of his own psychology, as castrating. Her dreams

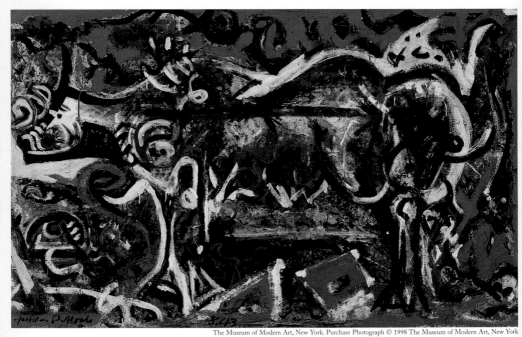

of the good life kept the family moving from town to town in search of an elusive prosperity. Yet while she terrorized her husband and sons with her needs, she was also reassuring and supportive. Pollock would return to images of his mother throughout his life, perhaps most notably in the painting named (appropriately) *The She-Wolf* (1943). Elizabeth Feinberg Pollock, Jackson Pollock's sister-in-law, later recalled that Stella "saw all her sons as potential geniuses and wanted them to be artists. But Jackson was the one she adored." Lee Krasner, the woman he eventually married, would possess many of his mother's stern, domineering traits.

- Pollock's father, **LeRoy Pollock** (1876–1933), was shy, detached, and had trouble holding a job. His surname at birth was McCoy, but he assumed his adoptive parents' name, Pollock, when they

OPPOSITE
The She-Wolf
1943
Oil, gouache,
and plaster on
canvas, 41 $^7/_8$ x 67"
(106.4 x 170.2 cm)

FYI: Pollock's brothers were Charles Cecil (b.1902), Marvin Jay (b.1904), Frank Leslie (b.1907), and Sanford LeRoy (1909–1963). Sanford changed his surname from Pollock to his father's birth name, McCoy, in 1942. His son, Jason, owns the Jason McCoy Gallery in New York City.

adopted him in 1897, after his own parents died. As LeRoy's children grew older, he traveled frequently for work, and in his correspondence with his sons he admitted that he had been of little help to them in finding their way in life.

■ Pollock was the **youngest of five boys.** Though pampered, he was withdrawn, depressed, and nonverbal. His mood swings ranged from pathological introversion to explosive anger. He had problems expressing himself in words and often behaved toward others with animal fury.

A Family on the Move

When Pollock was ten months old, his family moved to San Diego, California, and, a year later, to Phoenix, Arizona, where his father bought a truck farm. The venture would go bust within four years and the Pollocks would shift among various towns in California, always staying briefly and pushing on for "success" elsewhere. Within his first ten years of life, Pollock would inhabit six homes in three states as his father moved from job to job with little advancement. *Whew! That's a lot of moving!*

Sound Byte:
"The Wild West rides up out of the Pollock...."

—FRANK O'HARA, poet and curator, in his poem
"Favorite Painting in the Metropolitan"

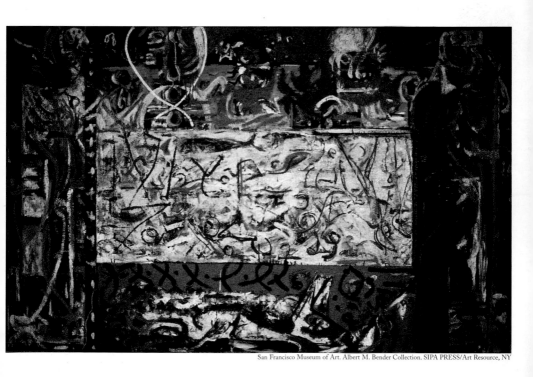

San Francisco Museum of Art. Albert M. Bender Collection. SIPA PRESS/Art Resource, NY

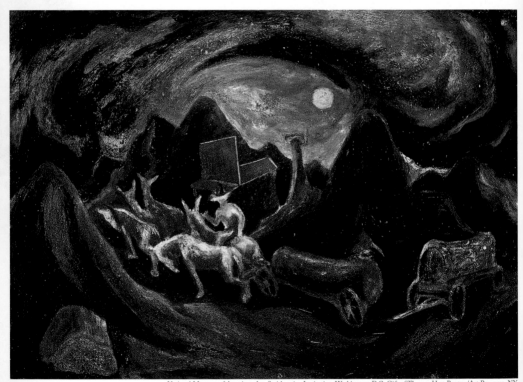

Discovery of Native American Art

In 1923, LeRoy moved his family back to Phoenix in pursuit of work on a nearby dairy farm. It was during this period that the 11-year-old **Jackson first visited Indian reservations and ruins,** observing the striking abstract patterns in the Native American Indian art and its use of sand, natural fibers, and raw materials.

Months later, in the spring of 1924, the family was on the move yet again, ending up in Riverside, California, where LeRoy found work as a surveyor.

Wild West days

In the summer of 1927, the teenage Pollock traveled with his father and brother Sanford to work on geologic and topographic surveys of the Grand Canyon. There, he worked alongside older men, eating and drinking with them—already showing **signs of alcoholism** in his freewheeling consumption of wine and beer, though this may have

OPPOSITE
Going West
1934-35
Oil on
fiberboard
15 ⅛ x 20 ¾"
(38.4 x 52.7 cm)

Sound Byte:
"Whatever Jackson felt, he felt more intensely than anyone I've known; when he was angry, he was angrier; when he was happy, he was happier; when he was quiet, he was quieter."

　　　　　—LEE KRASNER, speaking of her husband after his death

OPPOSITE
Woman
1930–33
Oil on masonite
14 x 10 ½"
(35.6 x 26.7 cm)

OVERLEAF
T. P.'s Boat in Menemsha Pond
c. 1934
Oil on tin
4 ⅝ x 6 ⅜"
(4.63 x 16.2 cm)

been his adolescent way of trying to fit in with the guys, be a macho man, and live the life of the Wild West.

Throughout his life, Pollock would trade on this "Wild West" background as a kind of identity, often drinking and brawling in bars like a cowboy in an old-time saloon. But at the time, he was still an impressionable teenager searching for identity.

Art as an Emotional Release

Pollock was bad at schoolwork and was a social misfit. Art—and especially drawing—was his one consolation, and he focused on it from an early age. **Drawing allowed him to turn inside,** to express his raging emotions on the page, and to find meaning detached from the outside world.

Troubled Adolescence then Self-Identity as an Artist

Moody and rebellious, he was kicked out of Manual Arts High School in Los Angeles twice during the school year of 1928–29 and lived the freewheeling life of a rebel and failure, like the roles of outcast heroes

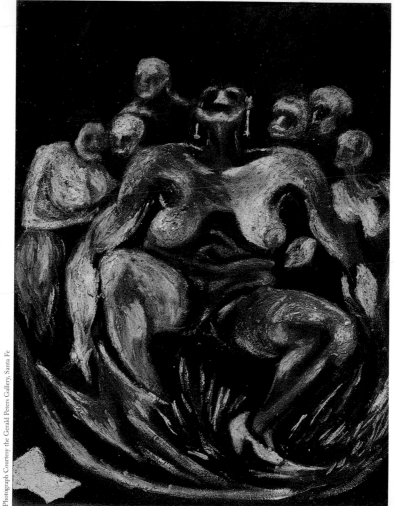

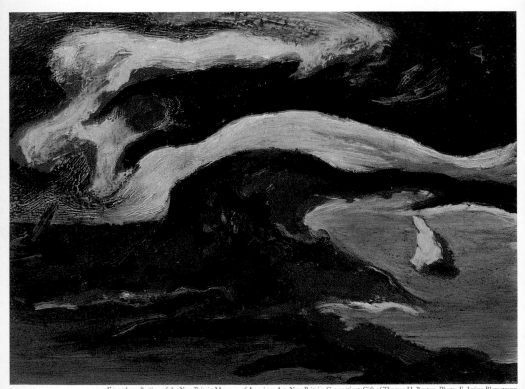

in Hollywood movies: think of Marlon Brando, James Dean, Montgomery Clift.

As he wrote to his brothers Charles and Frank, who had moved to New York to pursue their studies (Frank in literature, Charles in art): "This so-called happy part of one's life—youth—to me is a bit of damnable hell. If I could come to some conclusion about myself and life, perhaps then I could see something to work for. My mind blazes up with some illusion for a couple of weeks then it smolders down to a bit of nothing. The more I read and the more I think, the darker things become."

An Encounter with A Mystic

Through the guidance of a sympathetic art teacher, **Frederick Schwankovsky,** the 15-year-old Pollock received the fundamentals of an art education (incidentally, Pollock's first artistic interest was in sculpture). The same teacher introduced him to Buddhism and **Theosophy,** a Western movement based on Eastern principles, with special focus on mystical insights into the nature of God. Eventually Pollock became deeply interested in the teachings of the California-based Hindu mystic, **Jiddu Krishnamurti** (1895–1986), a

BACKTRACK: REGIONALISM

Regionalism was a realist movement of the 1930s, also referred to as American Scene painting. It celebrated regional (e.g., midwestern, southern) aspects of the American experience, partly in reaction to other, more Eurocentric modern art movements brought to New York in the early 20th century. The two best-known practitioners of regionalist painting were Thomas Hart Benton (1889–1975) and Grant Wood (1891–1942). Regionalism gained its greatest following during the Depression, when state-funded arts projects encouraged artists to celebrate their local surroundings. The movement fell out of favor toward the beginning of World War II, as people moved away from the regionalist and socialist themes of Depression-era murals.

former leader of the Theosophy movement who preached happiness through self-discovery. This interest in self-discovery and self-revelation would become a lifelong theme in Pollock's art.

By age 17, though miserable and lacking self-confidence, Pollock had a vague sense of what he wanted to do with his life. While studying life drawing and clay modeling in high school, he confessed in a disarmingly vulnerable letter to his brothers: "I am doubtful of any talent, so whatever I choose to be, will be accomplished only by long study and work. I fear it will be forced and mechanical. Architecture interests me, but not in the sense painting and sculpturing does…. As to what I would like to be, it is difficult to say. **An Artist of some kind.** If nothing else I shall always study the Arts. People have always frightened and bored me, consequently I have been within my own shell." None of his high-school drawings survive.

The Antisocial Artist arrives on the New York Art Scene

In 1930, at age 18, a restless Pollock moved East to become an artist in New York City. He joined his brothers Frank and Charles there, settling in Greenwich Village and enrolling at The Art Students League (also known as the ASL).

At the League, Pollock studied with the Regionalist painter **Thomas Hart Benton** (1889–1975), whose large, bold, energetic paintings were

among the most celebrated of the prewar era. Pollock's brother Charles had been studying with Benton since 1926. Benton's strong sense of painterly rhythm and composition were values Pollock quickly adopted as his own, and Benton soon became Pollock's mentor and friend.

During the early 1930s, Pollock occasionally returned home to visit his parents in California by hopping freight trains. He also took summer employment as a lumberjack, which helped pay his New York living expenses and art-school tuition.

Courtesy The Anschutz Collection. Giraudon/Art Resource, NY

Early Training and Influences

The Missouri-born Benton recognized Pollock's raw talent and also loved his Western background and manner. He encouraged Pollock to retain the independent, boisterous spirit of the Wild West instead of adopting the snooty tone of the Eastern Establishment.

The vulnerable and lonely Pollock was welcomed by Benton and his wife, Rita, as a kind of surrogate son. He remained in Benton's classes for five semesters. To support himself during these early years of the Depression, he took on odd jobs at the League and served as babysitter for the Bentons' young son, **"T.P."** (as in *T.P.'s Boat on Menemsha Pond*, page 22). In mid-1930, he took extended visits to the Bentons' summer cottage on Martha's Vineyard.

During the period of this close acquaintance, Pollock absorbed a number of influences from Benton, including Benton's interest in classical figurative art, specifically the bright, lusty, monumental paintings of the great Baroque artist **Peter Paul Rubens** (1577–1640). These awarenesses would be of great use to Pollock as a mature artist.

- Pollock's other early influences were the dramatic, almost hallucinatory Mannerist images of the Spanish painter **El Greco** (1541–1614) and the mystical landscape paintings of the eccentric American artist **Albert Pinkham Ryder** (1847–1917). Benton had encouraged his students to analyze the old masters with two ideas in

OPPOSITE
Man, Bull, Bird
c. 1938–41
24 x 36"
(61.0 x 91.4 cm)

mind: first, to study the linear rhythms in each painting; then, to zero in on the painters' depictions of their figures as geometric forms (which Benton called "cubic forms").

OPPOSITE
*Landscape
with Steer*
c. 1936-37
Lithograph
printed in black
with airbrush
additions in color
composition:
13 13/16 x 18 9/16"
(35.1 x 47.1 cm)

- In his drawing classes, Benton focused less on the kind of story-telling realism that is found in his paintings than on the analysis of the formal properties of art. He stressed technique over content or subject matter.

- In Pollock's efforts to absorb Benton's lessons, he spent time visiting museums and studying old masters, then retreated to his apartment and made drawings in his **sketchbooks** (see page 33). These sketchbooks, filled with drawings in the style of Rubens and El Greco, concentrate on the tumultuous stories from the life of Christ and the Virgin Mary. His early attempts to follow Benton's instructions on studying the rhythm of "lines" in paintings show many linear, geometric figures drawn in a style that anticipates the forcefully curving lines, block forms, and energetic angles of Pollock's Poured paintings of 1947–50.

Within five years of arriving in New York, Pollock supported himself by joining the mural division of the Federal Arts Project of the **WPA** (Works Progress Administration, the agency that instituted public works to relieve unemployment from 1935 to 1943). While there, he assisted with large public murals in government-owned buildings.

The Bentons leave New York

At the age of 23, Pollock was devastated when the Bentons left New York for Kansas City, Missouri. The drinking he had begun in adolescence led to repeated bouts of alcohol-related mental illness and depression. Years later, Sanford McCoy's wife, Arloie, recalled that Pollock would become unusually quiet or depressed for a few days before going on a binge. The binge would then be followed by a period of solitude and depression. When he sobered up, Pollock would return to painting and drawing.

Alcoholism and Mental Illness

A friend of Pollock's wrote to the Bentons, informing them that Pollock had begun drinking heavily after their move and had spoken of suicide. His older brother Sanford, who shared an apartment with Pollock at 46 East 8th Street, worked hard to help get Pollock straightened out. Writing to his family, Sanford noted that "Jackson has been having a very difficult time with himself. This past year has been a succession of periods of emotional instability for him, which is usually expressed by a complete loss of responsibility both to himself and to us. Accompanied, of course, with drinking. It came to the point where it was obvious that the man needed help. He was mentally sick. So I took him to a well recommended Doctor, a psychiatrist. Troubles such as this are very deep-rooted, in childhood usually, and it takes a long while to get them ironed out."

Even Thomas Hart Benton, himself an alcoholic, tried unsuccessfully to influence his former student in a letter, writing, "I saw your stuff in N.Y. And later a picture that my brother has. I am very strongly for you as an artist. You're a damn fool if you don't cut out the monkey business and get to work." It was clear that Pollock needed professional help.

Early in 1937, he began receiving Psychiatric Treatment for Alcoholism

In December 1937, Pollock accepted an invitation from the Bentons to spend Christmas with them in Kansas City. He enjoyed the trip, but this visit effectively concluded their period of close friendship. On June 9, 1938, Pollock was fired from his job at the WPA for "continued absence." He spent the next two days in a drunken stupor, then was admitted on June 11 as an inpatient for acute alcoholism at the Westchester Division of New York Hospital in White Plains. He remained hospitalized there until late September 1938 and did not paint, but he created copper reliefs and filled his sketchbooks with wild, psychosexual, exploratory drawings that reflected his inner conflicts. The sketchbook drawings, while showing the influence of Benton, are a fascinating record of Pollock's increasingly abstract visual explorations: As the world around him continued to fall apart, so too did the structure and linear forms of the world within his art. But with this "falling apart" came a new forcefulness of expression—in fact, an artistic breakthrough.

Interest in "Primitive Art"

Like many artists of his time, Pollock developed a taste for the so-called **"primitive art"** of Africa and America. The art that meant most to him from the mid-1930s to the early 1940s was by artists who had found similar inspiration in works of African or Native American Indian art, particularly the Spanish painter and sculptor **Pablo Picasso** (1881–1973) and the Mexican muralists **José Clemente Orozco** (1883–1949) and **David Alfaro Siqueiros** (1896–1974). He was intrigued by their use of archetypes, primitive imagery, and stylized figures, expressed in strong rhythms and lines, and by raw colors, with a preference for black. Even though the Mexican murals were largely political in content, Pollock admired them more for their esthetics and use of lines than for their subject matter. (Politics never did play a role in Pollock's paintings; his own concerns would remain, throughout his life, with personal and inner experience and with radical innovations in painting technique.)

Restless with the ideals of beauty promoted by Benton, Pollock was delighted to learn from the Mexican muralists that "great art could

FYI: Pollock studied under the influential Mexican muralist David Alfaro Siqueiros (1896–1974) when that artist opened an experimental work-shop at 5 West 14th Street in 1936. The studio remained open only for one year, however, since Siqueiros left for Spain in 1937.

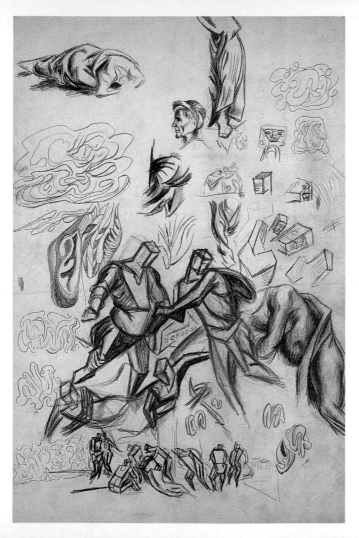

Untitled
Drawing from
sketchbook
late 1937–39
Colored pencils
and graphite pencil
on paper, 18 x 12"
(45.7 x 30.5 cm)

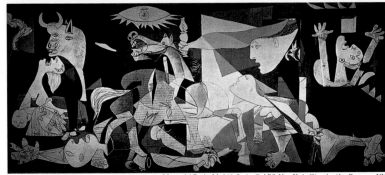

RIGHT
Pablo Picasso
Guernica. 1937
11' 6" x 25' 8"
(3.51 x 7.82 m)

OPPOSITE
José Clemente
Orozco
*The Epic of
American
Civilization:
Gods of the
Modern World*
(Panel #17)
1932–34. Fresco

OVERLEAF
Masqued Image
c. 1938–41
40 x 24 ¹/₈"
(102 x 61.3 cm)

also be ugly." The work of the muralists, and of "primitive" artists and craftsmen, impressed Pollock with its **furious and expressive nature,** for such qualities suited his own angry temperament. Pollock was also intrigued by the **signs and symbols** employed by these artists, which, according to Swiss psychiatrist Carl Jung, served as a link to a surreal, or unconscious, "dream" state. A good example of these qualities is to be found in Picasso's famous antiwar painting, *Guernica* (1937), which depicts the bombing and destruction in 1937 of the northern Spanish Basque town, Guernica, by German planes during the Spanish Civil War, and which was also based on Picasso's childhood memories of an earthquake. It is likely that Pollock viewed the painting in person, since *Guernica* was on display in New York twice in 1939 and 1940.

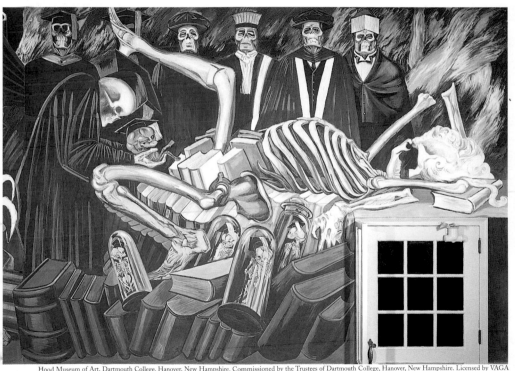

Carl Jung (1875–1961), one-time disciple of psychoanalyst Sigmund Freud (1856–1939), believed that each person is born with unconscious psychic material (the *collective unconscious*) common to humankind, accumulated by the experience of all preceding generations. Jung used the term *archetypes* to refer to the collectively inherited unconscious ideas, images, or patterns of thought that are universally present in individual psyches. Jung's preoccupation with dreams and the unconscious made his work deeply interesting to many Surrealist and Abstract Expressionist painters.

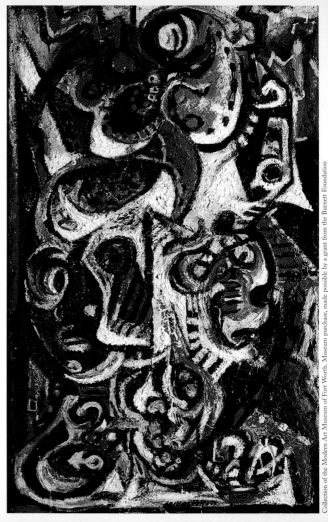

Collection of the Modern Art Museum of Fort Worth. Museum purchase, made possible by a grant from the Burnett Foundation

Jungian Therapy Leads to Surrealism

In 1939, Pollock began seeing a Jungian psychoanalyst, **Dr. Joseph L. Henderson.** But Henderson, who was in his first year of practice and had no firm ideas about how to treat Pollock, found his patient withdrawn and inarticulate. Treatment was at an impasse, and when Pollock could not discuss his problems openly, he began drawing pictures. The artist found he could speak more freely by using the drawings as a reference. Over the next 18 months, Pollock created 69 sheets of drawings (13 of which contained drawings on both sides) and one gouache painting which, he said, demonstrated different aspects of his illness and unhappiness. (A *gouache* is a painting in opaque watercolors, which have a kind of "chalky" look.)

In later years, Dr. Henderson admitted the failure of the treatment, writing in an unpublished essay, "I wonder why I neglected to find out, study, or analyze his problems in the first year of his work…. I wonder why I did not seem to try to cure his alcoholism…. I have decided that it is because his unconscious drawings brought me strongly into a state of counter-transference to the symbolic material he produced. Thus I was compelled to

BACKTRACK: SURREALISM

Surrealists experimented with psychic *automatism*, in which the artist lets his or her unconscious impulses guide the hand in matters of line, color, and structure, without rational, planned "interference." This enabled the artist to express an inner state. The ideas behind automatism were later incorporated into Abstract Expressionism. André Breton (1896–1966), a major French Surrealist artist and intellectual, defined Surrealism as a "pure psychic automatism, by which one intends to express verbally, in writing or by any other method, the real functioning of the mind… [It is an art form] based on the omnipotence of dreams."

OPPOSITE LEFT
Untitled (Naked Man with Knife)
c. 1938–41
50 x 36"
(127 x 91.4 cm)

OPPOSITE RIGHT
Naked Man
c. 1938–41
Oil on plywood
50 x 24"
(127 x 61 cm)

follow the movement of his symbolism as inevitably as he was motivated to produce it." The treatment ended when Henderson decided to relocate to San Francisco.

During 16 months of treatment, Pollock created 83 drawings filled with animals and monsters, naked women, shamans, and totems. Pollock's experimentation was close in spirit to the work of a number of Surrealist artists who had moved to New York at the outbreak of World War II. Pollock's interest in dreams, the unconscious, and Surrealism led to yet another breakthrough in his art. His brother Sanford described it plainly in a letter to Charles Pollock: "After years of trying to work along lines completely unsympathetic to his nature, Jackson has finally dropped the Benton nonsense and is coming out with an honest creative art."

Sound Byte:
"Jackson Pollock was the best colorist America ever had."
—THOMAS HART BENTON

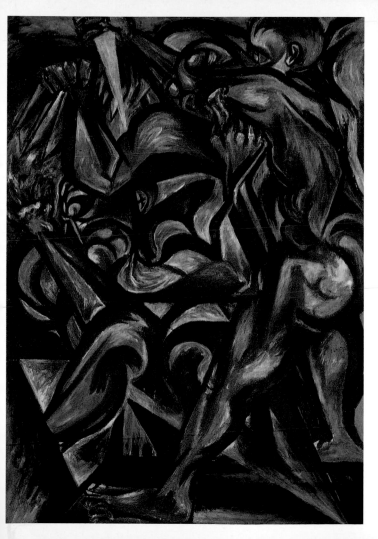

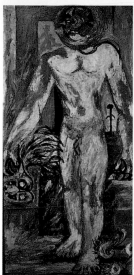

Above: Private Collection. **SIPA PRESS**/Art Resource, NY. *Left:* Tate Gallery, London/Art Resource, NY

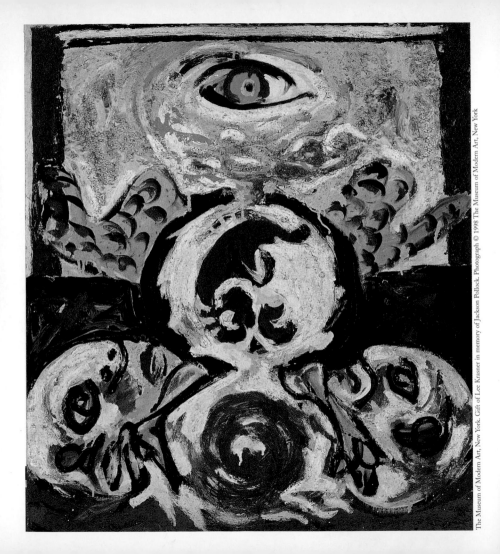

An Early Mentor and Mystical Influence: John Graham

Another significant early mentor to Pollock was the artist, curator, mystic, and author **John Graham** (1881–1961). Born Ivan Dambrowski in Kiev, the Russian émigré came to the USA in the early 1920s. His eccentric paintings straddle realism, abstraction, and Surrealism. In an article entitled "Primitive Art and Picasso," Graham stated that "primitive races and primitive genius have readier access to their unconscious mind[s] than so-called civilized peoples." As a result of this access, he believed that "primitive" people had deeper knowledge of the cosmos.

As curator of the Crowninshield Collection of Primitive Art, which was installed at the Metropolitan Museum of Art, Graham was an authority on African masks and he introduced Pollock to the idea of "the artist as shaman," an idea that would eventually propel Pollock to celebrity status as a cultural hero. Graham felt that the Artist was the shaman, or medicine man, of contemporary society—one who communes with the world of the spirits for the benefit of all humankind. Upon meeting Pollock, Graham decided that the troubled, socially maladroit artist was the **embodiment of the "Primitive/Genius,"** a man so deeply attuned to the troubles of the spirit world that he could barely function in society.

OPPOSITE
Bird. 1941
Oil and sand
on canvas
27 ¾ x 24 ¼"
(70.5 x 61.6 cm)

Sound Byte:
"Starting a painting is starting an argument in terms of canvas and paint."
—JOHN GRAHAM

Graham was perhaps the first person to celebrate Pollock's troubled personality and strongly antisocial behavior as proof-positive of his mystical insight as an artist. As far as Graham was concerned, artists were entitled to their personal eccentricities by virtue of their deep, mystical attachment to the spirit world. Graham's opinions of Pollock were an important contribution to Pollock's eventual celebrity, for they helped critics to reconcile Pollock's troubled and often aggressively unpleasant personality with his highly accomplished work as an artist.

Behind Every Great Man...

In November 1941, John Graham invited Pollock to exhibit in a show he was organizing at the McMillen Gallery. The artist **Lee Krasner** (1908–1984) was invited as well. Later, upon learning that Pollock lived just around the corner from her, she decided to visit him—thus beginning the relationship that would last until his death. Krasner, a first-generation Russian Jew, had changed her name from Lena Krassner to Lee Krasner after moving from Brooklyn to the

OPPOSITE
Pollock and
Krasner

Sound Byte:
"What he had done was much more important than just line. He had found the way to merge Abstraction with Surrealism."

—LEE KRASNER, describing an early meeting with her future husband, Jackson Pollock

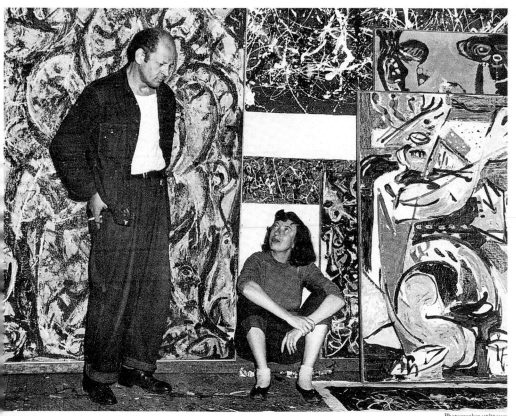

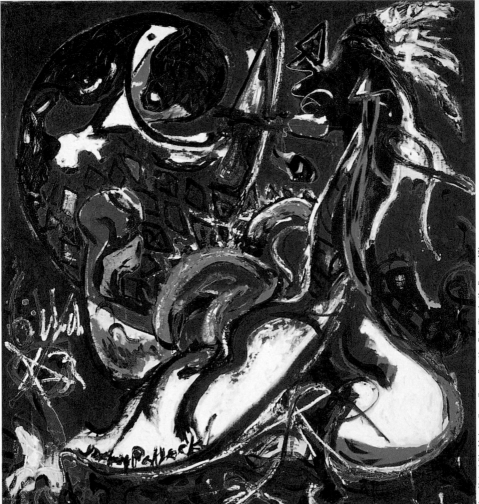

Manhattan art world. An ambitious go-getter with a strong personality, Krasner was well established in her career when she met Pollock. During the 1930s, she had worked on the Federal Arts Projects, and from 1938 to 1940 she studied with the German-born American teacher and painter, **Hans Hofmann** (1880–1966). Though Krasner and Pollock were prone to argument and conflict, Krasner's love for him was strong and nurturing.

OPPOSITE
*The Moon-Woman
Cuts the Circle*
c. 1943. 42 x 40"
(107 x 102 cm)

The motherly Krasner shared Pollock's interests in art, literature, and mysticism—and she enthusiastically supported his radical ambition. Soon they were not just lovers, but also the closest of friends.

Pollock was drawn to Krasner not for the superficial good looks of a "trophy wife," but for her talent, strength, intelligence, and richness of character. Unlike Pollock, who was withdrawn and psychologically fragile, Krasner was strong, organized, and fiercely aggressive. She recognized Pollock's genius and was prepared to fight for his recognition. For the rest of his life, Pollock relied heavily upon Krasner in his business and personal affairs, as well as in matters of physical and mental health.

Though for many years Lee Krasner was known to the public merely as Pollock's wife and, after his death, as the guardian of his estate, Krasner continued to paint while married to him and had a long and successful career after his death. Today she is recognized as one of the foremost Abstract Expressionist painters.

In Search of a Gallery: Enter Peggy Guggenheim

In Lee Krasner, Pollock had found a girlfriend/ mother/ business manager. He was having artistic breakthroughs; now all he needed was a top New York gallery to show his work. Enter **Peggy Guggenheim** (1898–1979), her Surrealist friends, and her Manhattan gallery.

Peggy Guggenheim will doubtless be remembered as one of the most extraordinary women of the New York art world. Fabulously wealthy, endlessly eccentric, deeply enthusiastic about art, Peggy Guggenheim was also an incredibly strong personality—truly a force to be reckoned with.

- The niece of philanthropic copper tycoon, **Solomon R. Guggenheim** (1861–1949), whose art collection would one day become the Guggenheim Museum in New York City, Peggy moved to Europe in 1920, where she began collecting art. She returned to New York with her art collection at the outbreak of World War II.

> **FYI:** At the moment when Peggy Guggenheim met Jackson Pollock, the artist was seriously broke. In January 1943, Pollock was making ends meet by working as a part-time custodian in the Museum of Non-Objective Painting, also known as the Solomon R. Guggenheim Collection. In other words, at the time Peggy discovered him, Pollock was working for Peggy's uncle!

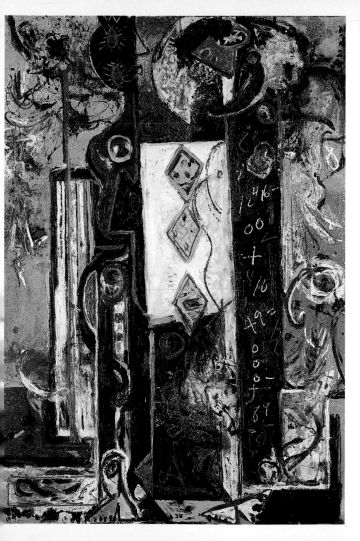

ABOVE
Peggy Guggenheim

LEFT
Male and Female
c. 1942. 73 x 49"
(185 x 125 cm)

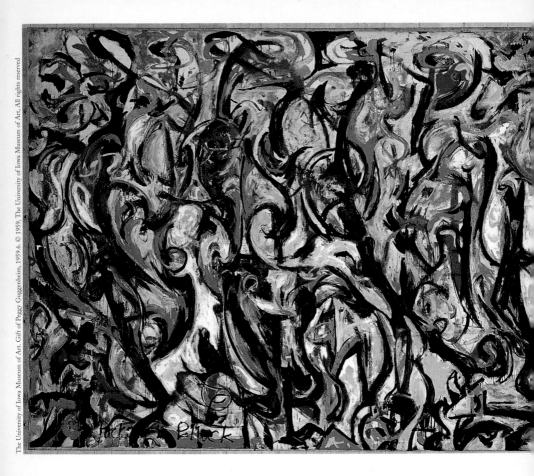

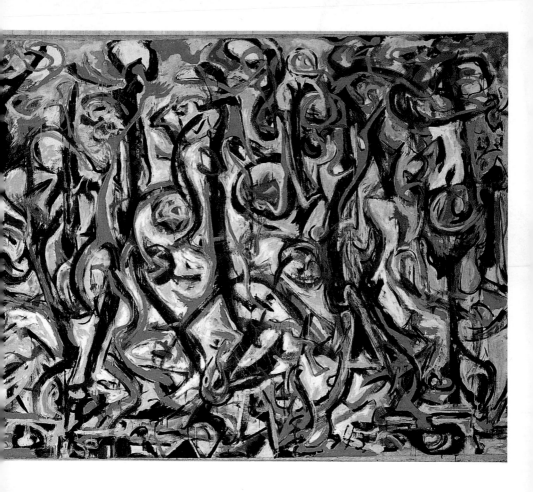

- By the mid-1940s she had divorced her first husband, Laurence Vail, and married the renowned Surrealist artist **Max Ernst** (1891–1976).

- Guggenheim then became the owner and backer of the **Surrealist Gallery,** an experimental and architecturally innovative space, showing the work of her current husband as well as that of his friends, **André Breton** (1896–1966), **Marcel Duchamp** (1887–1968), and **Roberto Matta Echuarren** (b. 1911), the Chilean painter known professionally as **Matta.**

Luckily for Pollock, the temperamental Guggenheim was about to divorce Max Ernst (who had recently abandoned her for another woman) and was eagerly looking for a new group of artists to promote in her gallery. Matta introduced her to Pollock in 1943. Pollock showed his first painting at her new gallery, **Art of This Century,** at 30 West 57th Street, in Guggenheim's Spring Salon for Young Artists, May 18–June 26, 1943. His painting, *Stenographic Figure,* received a very strong positive response, including a glowing mention in the critically important magazine, the *Nation.* The result, as Pollock reported to his brother Charles in July of 1943, was, "I have a year's contract with the Art of this Century and a large painting to do for Peggy Guggenheim's house…with no strings as to what I paint it." The work Pollock subsequently created for Guggenheim would be his breakthrough large painting, *Mural* (we'll get to that in a moment).

Pollock's First Show

Peggy Guggenheim held Pollock's first show on November 8, 1943, touting the exhibition to the press as "an event in the contemporary history of American Art." The review in *The New York Times* agreed, raving that "Pollock's talent is volcanic!"

In subsequent months, more critical opinions would emerge strongly in Pollock's favor. "Pollock is in a class by himself," the influential critic **Clement Greenberg** (1909–1994) would observe. Years later, in 1952, Greenberg added, "Others may have greater gifts or maintain a more even level of success, but no painter in this period *realizes* so strongly, so truly, or so completely. Pollock does not offer samples of miraculous handwriting, he gives us achieved and perfected works of art."

First Really, Really BIG Work: *Mural*

Pollock's first large work, *Mural* (1943), was an enormous canvas measuring 8' ½" x 19' 10" designed specifically for the entrance foyer of Guggenheim's residence on East 61st Street in Manhattan. The work was painted on canvas at the suggestion of the Surrealist painter Marcel Duchamp. In that way, the work could be moved, shown and/or sold—unlike an ordinary mural painted directly onto plaster. Thus a great innovation with which Pollock is credited—**large-sized paintings**—had in fact been suggested by a Surrealist friend!

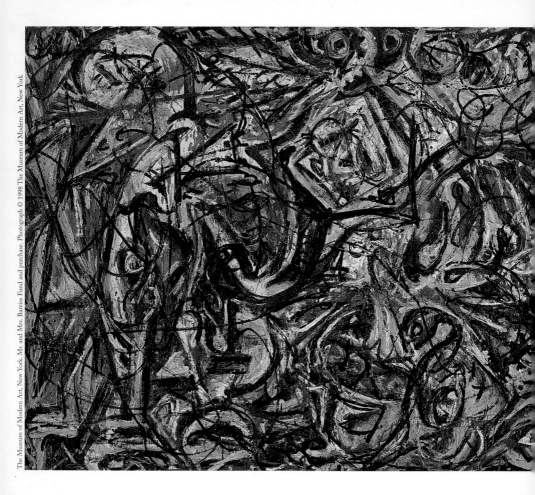

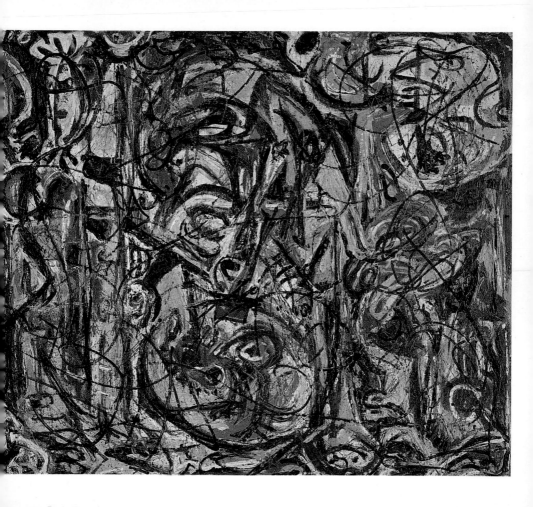

Moving Away from Surrealism

OPPOSITE
*Reflection of
the Big Dipper*
1947
43 ¾ x 36 ¼"
(111 x 92.1 cm)

Stedelijk Museum,
Amsterdam/Art Resource, NY

Like Peggy Guggenheim—though for very different reasons—Pollock soon began moving away from the Surrealists, in part because of his disillusion with Jungian analysis, but also because mythic symbolism no longer appealed to him.

Instead, he began to concentrate on **abstract patterns and rhythms** and to experiment with new painting techniques, which included working from an unprimed and unstretched canvas, often laying it on the floor rather than placing it upon a wall. "I feel nearer, more a part of the painting," he explained, "since this way I can walk around it, work from the four sides and literally be in the painting. This is akin to the method of the Indian sand painters of the west."

He also stopped using traditional painting tools like brushes and palettes. Instead, he experimented with sticks, trowels, and knives, and tried dripping fluid paint or a heavy impasto (a fancy word for very thick paint) with sand, broken glass, and other foreign matter added.

Pollock also began to take a more *organic* approach to the process of painting. "When I am in the painting, I'm not aware of what I'm

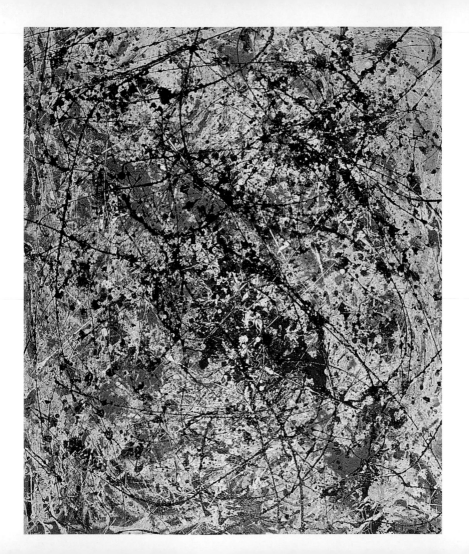

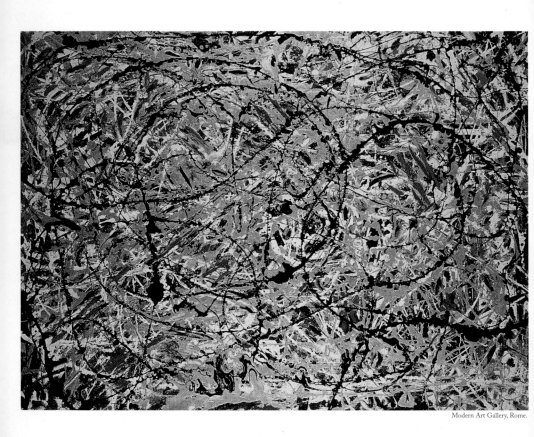

doing. It's only after a sort of 'get acquainted' period that I see what I have been about. I have no fears about making changes, destroying the image, etc., because the painting has a life of its own. I try to let it come through." To his good friend, the author and art connoisseur B.H. Friedman, he eventually went even further, observing that "my concern is with the rhythms of nature."

OPPOSITE
*Undulating Path*s
(also known as
Watery Paths)
1947

During the period of 1943 to 1947, Pollock had three solo shows at Art of This Century, renegotiated his contract with Peggy Guggenheim, and married Lee Krasner on October 25, 1945 at the Marble Collegiate Church in Manhattan. Most important, he bought a tumble-down little farmhouse in The Springs, near East Hampton, Long Island, where the couple began to live full-time.

Rural Bliss (Sort of)

The Pollocks' move to The Springs signaled a change in his life. Through Krasner, he had already begun a course of **homeopathic healing and medicine**, which soon replaced Jungian analysis in his thoughts and in his life. After settling into their new home, Pollock and Krasner began to enjoy the **beauty and rhythm of nature.** Pollock stopped drinking, took up vegetable gardening, and concentrated on his painting. He and Krasner took walks on the beach, collected rocks and shells and driftwood, and spent evenings admiring the sky. *This sudden awareness of nature strongly influenced Pollock's work.*

Though the boredom and frustration of an isolated rural life eventually took its toll on the couple's happiness, their first years were relatively content and—once the ramshackle house and garage had been cleaned out and fixed up—highly productive. Their little house overlooked a watery meadow and, beyond it, the sea. Pollock did some of his finest paintings at this little farmhouse, which today has been converted into a shrinelike museum and study center. The house suited him because it resembled the farmhouses in which he had grown up, and the flat, open-skied landscape reminded him of the best moments of his childhood. As he told an interviewer, "I have a definite feeling for the west: the vast horizontality of the land, for instance: here only the Atlantic ocean gives you that."

The Springs was a quiet, working-class area, far from the wealth and pretense of New York City, and yet not too far from the summer homes of a number of wealthy New York art collectors and culture aficionados. Pollock felt more at home living among working-class people, but he needed a home that was close to his New York clients and the New York art scene. Living in a house in the country, tended by a wife who was interested in homeopathic and holistic living, Pollock was far from the immediate temptations of alcohol. During his first years in the country, he successfully stopped drinking and focused on his work.

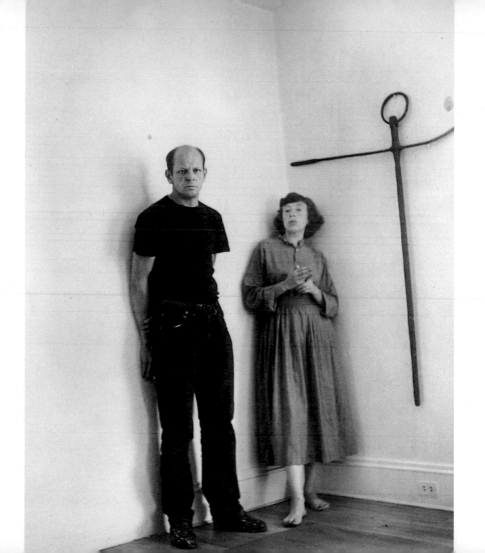

Back in New York: Exit Peggy, Enter Betty

By late 1947, Peggy Guggenheim had decided to close Art of This Century. With some difficulty, she managed to persuade art dealer **Betty Parsons** (1900–1982) of the Betty Parsons Gallery to take on Pollock, who was on the verge of a major artistic breakthrough: Drip painting.

Parsons, one of the most famous art dealers of the 20th century, but far from the most financially successful, had studied sculpture before becoming a dealer. She had been the director of two galleries and had worked in several others before opening her own place in 1946. Her stable of artists would eventually include **Mark Rothko** (1903–1970), as well as Jackson Pollock. A taste-maker and intellectual, Parsons is today considered one of the great visionary presences of 20th-century art.

The Birth of Drip Painting

Pollock is best remembered and most famous for his Drip paintings, but it was only during the years 1947–51 that he worked in the purely Drip method.

Looking at a Drip Painting

Here's what to look for in the famous Drip paintings:

1. There is **no compositional center** (or "focal point").

2. The **different colors** of paint are not applied one after the other, but **weave in and out**; occasionally, the colors mix together and seem to **melt into one another**.

3. The paint is laid on in certain **rhythmical patterns**.

4. The painting overall has **energy and exuberance**.

5. They're really **kind of pretty!**

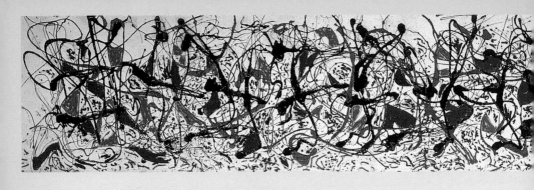

Intermission: Pollock Titles and Museum Labels

Let's take a brief intermission at this, the height of Jackson Pollock's career, to discover something about the titles and numbers attached to Jackson Pollock paintings.

Pollock's paintings often go by several different titles. This is more complicated than you think, so beware. Each work has an official title, but some works are known by unofficial titles, and some works are known by several titles—either official, unofficial, or both. Confused? Read on!

OFFICIAL TITLES

According to the catalogue raisonné of Pollock's works (a catalogue raisonné is the "official catalogue" of an artist's entire body of work, usually published after his/her death), titles are ***official*** if they were

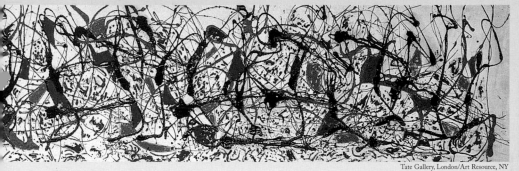

published during Pollock's lifetime, or were testified to by Lee Krasner during her lifetime, or were otherwise documented by Krasner (in letters, contracts, etc). In the case of early, "pre-Krasner" works, the titles on the back of WPA photographs, or titles recalled by Thomas Hart Benton and the Pollock family, were also accepted for the official designation. **Official** titles are never placed in quotation marks. They are simply stated. A good example of this is the painting *The She-Wolf*.

Summertime: Number 9A, 1948 1948. Oil and enamel on canvas 33 ¼" x 18' 2" (84.5 cm x 5.54 m)

UNOFFICIAL TITLES

Unofficial titles are titles that have become standard through usage and publication, but were not given by Pollock, Krasner, Benton, or the Pollock family. These are placed in parentheses when labeled or mentioned in official catalogues. A good example of an unofficial title that has become standard through usage is the title *(Orange Head)*.

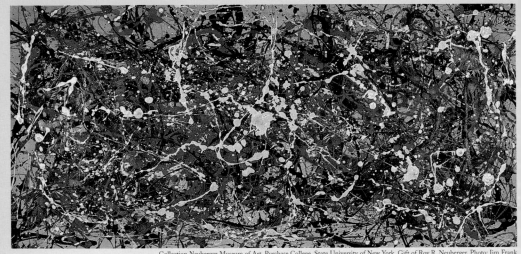

Collection Neuberger Museum of Art, Purchase College, State University of New York. Gift of Roy R. Neuberger. Photo: Jim Frank

TITLES THAT ARE EVEN LESS OFFICIAL THAN UNOFFICIAL TITLES

After the *Unofficial Titles* come **titles given by owners to otherwise untitled works.** These titles are enclosed in quotation marks. A good example of an unofficial title given by an owner is the title *"Dancing Head."*

Wait a minute—Why are there numbered titles and verbal titles?

The truth is, many Pollock works have **both numbered titles and verbal titles,** such as *Lavender Mist: Number 1, 1950.* Pollock gave numbered titles instead of verbal ones to his Poured paintings after 1947. This was done to avoid giving too much weight or "meaning" to an abstract work

64

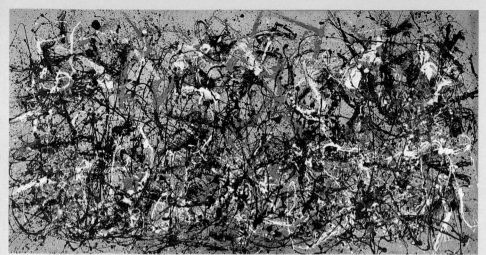

through a verbal title, yet establishing a practical means for distinguishing one work from another. Sometimes, however, Pollock gave the paintings verbal titles as well, just because that was an easier way of referring to a painting. A good example of this is *Blue Poles*. Imagine Sidney Janis, the dealer, calling Jackson Pollock and asking which painting he should try to sell for eight thousand dollars. Jackson, a little groggy, can't think of the number of the painting, so instead says, "Aw, c'mon, Sidney—just the one with the blue poles!" Voilà! A title is born!

If the existence of numbers and verbal titles seems complicated to you, you're not alone: Even the authors of the catalogue raisonné agree that this method has led to confusion about the "name" of a Pollock work.

ABOVE
Autumn Rhythm:
Number 30, 1950
105 x 207"
(266.7 x 525.8 cm)

WHAT ABOUT TITLES WITH NUMBERS FOLLOWED BY LETTERS?

Okay, but you may be sorry you asked. You've probably noticed that sometimes the letter "A" appears in a numbered title (e.g., *Number 1A, 1948*). What does it mean? Well, the "A" indicates that a work did not sell in its first show. The decision to add the "A" to the title was made by Pollock's gallerist at the time, Betty Parsons. When both titles are Pollock's, they are separated by a colon. Otherwise they are separated by a slash. The title most commonly cited in the literature is given first.

OPPOSITE
*Number 1A,
1948*. 1948
Oil and
enamel on
unprimed canvas
68" x 8' 8"
(172.7 x 264.2 cm)

Examples:
Blue Poles: Number 11, 1952
Number 8, 1951/ "Black Flowing"

QUIZ TIME!

Now, what do you know about the following two paintings, based on the way in which they are labeled? You have thirty seconds.

Blue Poles: Number 11, 1952
Number 8, 1951/ "Black Flowing"

Answer: For as tricky as this all sounds, you now know that *Blue Poles* is the best-known title for a painting that Pollock and/or his wife knew as both *Blue Poles* and *Number 11, 1952*. You also know that *Number 8, 1951* is the title of the painting as Pollock and/or his wife knew it, but that the painting also has a second title, *Black Flowing*, given to it by its owner.

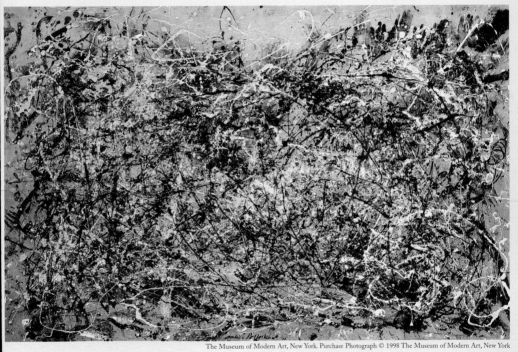

Intermission, Part Two: Museum Labels

Generally, when you go to a museum, each work is accompanied by a label. Some parts of the label are self-explanatory, others are not.

A label features the title of the work, the name of the artist, the year of the work's creation, the dimensions of the work (often given in both inches and centimeters), and a description of the media used to create the work ("oil on canvas," "pastel on paper").

If the work belongs to the museum, the label usually includes information about how the work came to the museum ("Museum Purchase," "Gift of Mrs. Joseph Smith," "Anonymous Gift," "Permanent Loan," "Trustees' Purchase") and an inventory or accession number that is important for the museum's own records, although of no use at all to most of us.

If the work is on loan for a special exhibition, rather than as part of the museum's own permanent collection, the owner of the work, the lending institution, or the words "anonymous collector" will describe where the work came from.

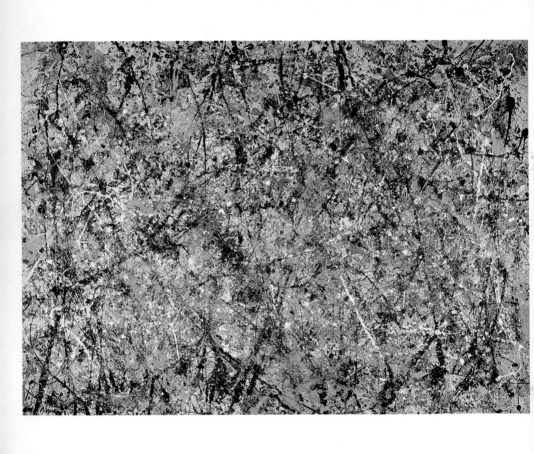

Wait a minute—Who Dripped First?

Pollock did not "invent" the Drip technique. Surrealists, including **André Masson** (1896–1987) and Max Ernst, had used the Drip method in their work since the 1930s as part of their doctrine of "pure psychic automatism." Hans Hofmann, whose work evolved from German Expressionism, was another abstract artist who celebrated the process of painting by using paint drips and splashes in his finished work.

But Pollock was the first artist to create entire works using the Drip technique. When asked the source of his innovative technique, Pollock credited his inspiration to Native American sand-painting artists in the American West, thus allying himself to an indigenous American tradition rather than to a European one.

The Six Innovations of Pollock's New, Exciting, and Controversial Drip Paintings

Pollock's formal innovations included the following:

1. **NEW! LARGER-SIZE CANVAS FOR ABSTRACT WORK**
 Pollock took the traditional easel painting—a work on canvas—and expanded it to mural size, thus asserting (through size) the heroic importance of the work he was doing—i.e., the exploration of his own psyche through abstract painting. *(And the critics loved it!)*

OPPOSITE
Lavender Mist: Number 1, 1950
1950
Oil, enamel and aluminum on canvas
87 x 118"
(2.210 x 2.997 m)
framed:
88 x 119 x 1 ½"
(2.235 x 3.023 x .038 m)

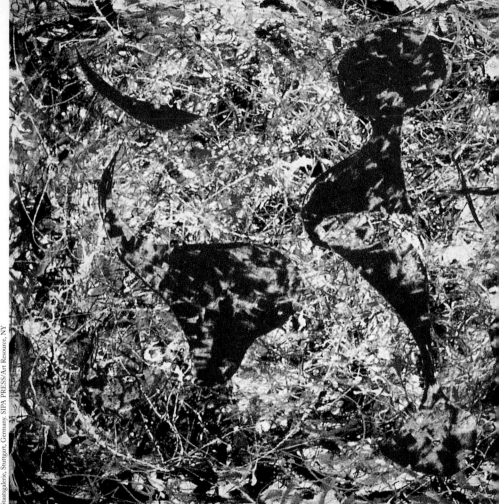

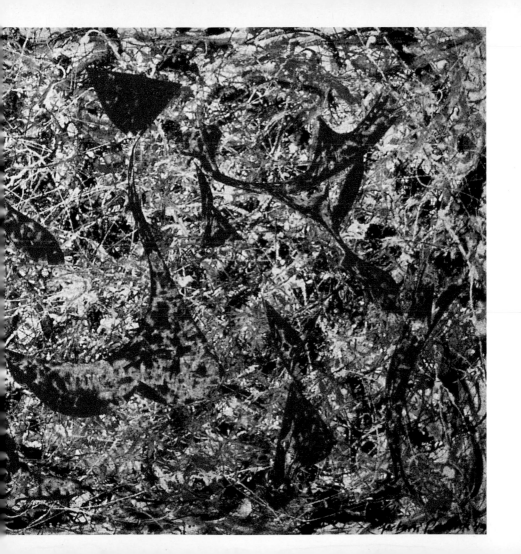

2. **NEW! PHYSICAL PRESENCE OF THE PAINTING**

Pollock wanted viewers to see that a painting was **not a representation** of something else (a meadow, a person, a house) but rather **a two-dimensional thing**. (Hello!—It's paint on canvas!) **Pollock refused to discuss subject matter** and insisted instead on the importance of the **immediate visual image.**

3. **NEW! PAINTERLY VOCABULARY**

Drips, spatters, splatters, dribbles, squiggles, smooshies, smudges, handprints, swirlies, poured-on stuff...*you get the picture.*

4. **NEW FOR THIS YEAR! GESTURAL AUTOMATISM (HUH?)**

Pollock hoped that through **painting without thinking** ("automatism"), he could **reach a deeper level of consciousness** in his painting, and thereby communicate some vital aspect or gesture of the human condition. (It might sound feeble now, but the critics ate it up then!)

5. **NEW AND IMPROVED! DE-EMPHASIS OF THE FRAME**

Pollock wanted the pattern or image on his canvases to seem to **extend indefinitely** rather than come to an end at the edge of the canvas or "frame." In fact, Pollock's Drip paintings were never framed, so that the image created by the painting did not appear to end with the borders of the painting, but seemed to **extend foreverrrrrrrrr..........**

6. ALL-NEW IDEA! THE PAINTING AS OPTICAL FIELD

Pollock's Drip paintings create an "optical" rather than "tactile" field. (Translation: It looks like what you see if you don't focus your eyes on anything—or, what you see if you close your eyes for awhile and start to see whirling colors and patterns. Test: Close your eyes. What do you see? Answer: a Jackson Pollock painting!) Other artists had previously experimented with the idea of the painting as an optical field, most notably the French Impressionist **Claude Monet** (1840–1926) in his large-scale paintings of water lilies. Pollock, however, created an **optical field** that was entirely non-representational. No water lilies, just paint!

Silent Artist, Articulate Critics

Pollock's unwillingness to discuss his work allowed eager critics to jump in on his behalf, in part to promote their own views and ideas about the controversial new forms of abstract art being created in New

York during the 1940s and 1950s. Smart fellow: By provoking art critics, Pollock assured himself a place in art history.

The leading advocate for Pollock's work was art critic **Clement Greenberg** (1909–1994), who wrote about abstraction and the avant-garde in the leftist political magazine, *Partisan Review.* As an ambitious editor and writer for that magazine, Greenberg wielded great power and influence in the art community. In fact, he came to art criticism through political philosophy, and much of his early criticism was informed by a strong awareness of Marxism and, particularly, Trotskyism (the form of communism based on worldwide revolution by the working class). Greenberg believed abstract art superior to all other forms, and "the most valid" art form of the moment. He based this judgment on a **historical analysis of culture** over the previous century and concluded that since abstraction had been proven by history to be the most culturally and intellectually important form of art, it was the dominant form of painting of the times. "Abstract art cannot be disposed of by a simple-minded evasion. Or by negation," he concluded in a landmark 1940 essay for *Partisan Review.* "We can only dispose of abstract art by assimilating it, by fighting our way through it."

Greenberg, who called this new style of art "American-type" painting, was not the only critic to write about Pollock's work. As a result, a "turf war" between critics soon erupted. **Harold Rosenberg** (1906–1978), writing for *ARTnews,* then the most important magazine of the New

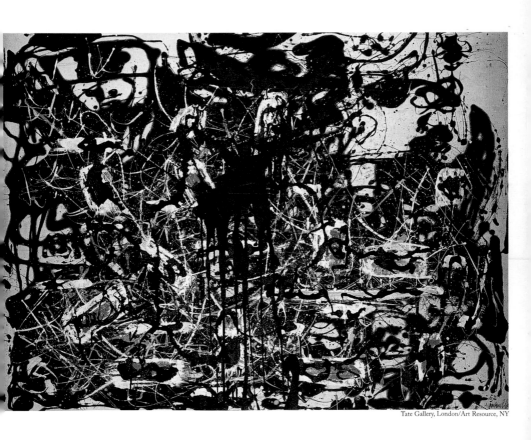

York art community, also praised Pollock's early work as a new kind of painting, in which the artist expressed the drama of his inner self through gestures in paint. But Rosenberg, who dubbed this new style of painting **"Action Painting,"** soon began to favor artist **Willem de Kooning** (1904–1997) over Pollock, leaving Greenberg the chief defender of Pollock as "the champ" and eventually causing the much-talked-about **Pollock/de Kooning rivalry** to erupt throughout the critical community (we'll get to that in a minute).

The Invention of "Abstract Expressionism"

With the excitement and controversy surrounding the radically different painting of Pollock, de Kooning, Rothko, and others, a new terminology was coined. In the end, neither Greenberg nor Rosenberg came up with the name by which we know Pollock's painting today. Greenberg wrote in the mid-1950s that "Robert Coates of *The New Yorker* invented abstract expressionism at least in order to describe American painting."

Other critics used their own terminology to describe Abstract Expressionism. The painter and critic **Fairfield Porter** (1907–1975) called it simply American Non-Objective Painting. For Porter, "the Impressionists taught us to look at nature very carefully; the Americans teach us to look very carefully at the painting." In American Non-Objective Painting, Porter concluded, "Paint is as real as nature and the means of a painting can contain its ends."

Back in the Studio, Filming Triggers Alcoholic Relapse

After Pollock had settled into his life in The Springs, many artists and friends came to visit, and among Pollock's immediate circle there was a growing awareness that the art Pollock was creating was little short of miraculous, and that the studio itself was a sort of "sacred ground."

The artist Robert Goodnough (b. 1917), visited Pollock at work in his studio and described it shortly thereafter in an article in *ARTnews*. "The floor is literally covered with large cans of enamel, aluminum, and tube colors—the boards that do show are covered with paint drippings. Three or four cans contain stubby paint brushes of various sizes. About the rest of the studio, on the floor and walls, are paintings in various stages of completion, many of enormous proportions. Here Pollock often sits for hours in deep contemplation of a work in progress, his face forming rigid lines and often settling into a heavy frown. A Pollock painting is not born easily, but comes into being after weeks, often months of work and thought."

In the autumn of 1950, photographer **Hans Namuth** (1915–1990) came to The Springs to visit Pollock and made **two films of Pollock painting** (the first, shot in the early days of fall, in black and white; the second, shot in the last days of October, in color). In the second, he filmed Pollock from below, through a pane of glass, while Pollock Drip-painted on the glass. These two short movies are perhaps the

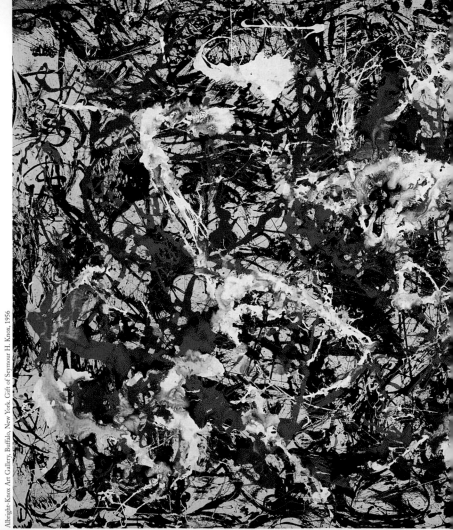

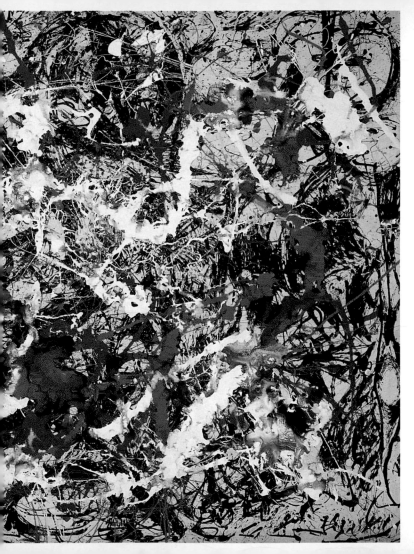

Convergence
1952
93 ½ x 155"
(237.5 x 393.7 cm)

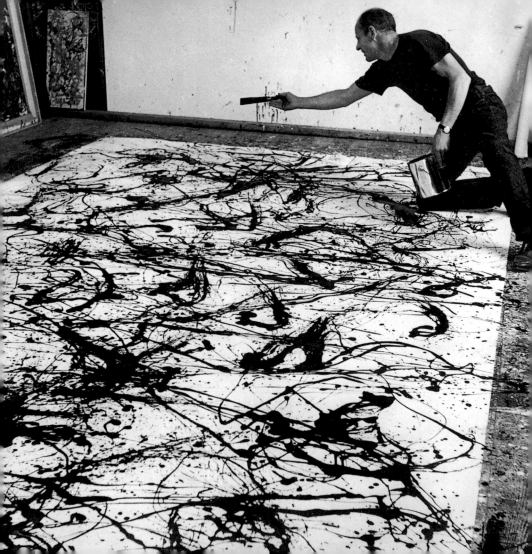

most famous short films of an artist at work. **They are invaluable documents of Pollock's work method.** (The piece of glass used in the film, now titled Number 29, 1950, is in the National Gallery in Ottawa, Canada).

Immediately after the filming, Pollock began drinking again. Having enjoyed two years of sobriety, he fell off the wagon. Fourteen friends had been invited for a pot-luck dinner that evening, and just as the meal was about to begin, Pollock, by this time drunk out of his mind, overturned the table and knocked food, dishes, bottles of wine, glasses, and silverware to the floor.

OPPOSITE
Pollock painting
1950
Photograph by
Rudolph Burckhardt

In the months that followed, Pollock suffered a period of intense self-consciousness and creative paralysis. The truth was, though he had spent most of his adult life seeking recognition as an artist, Pollock found that public attention depressed him, made him anxious, and inhibited his ability to work. The filming by Namuth had catalyzed these paralyzing feelings of self-consciousness.

Pollock's anxiety over his celebrity persona worsened five months later in March 1951, when his paintings appeared in a photo shoot by **Cecil Beaton** for *Vogue* magazine. Beaton had posed fashion models in front of Pollock's paintings at the Betty Parsons Gallery, with the caption "New soft look," thus defining Pollock to the American consumer public as **the last word in fashionable chic.**

Significance of the Hans Namuth Films

In the years since their creation, the Hans Namuth films of Pollock at work have taken on a life of their own. They have been made into a book, shown on television, and are frequently screened in museums. Popular among the art-viewing public for the "inside" glimpse of an artist in his studio, the movies are also considered by art historians to be the visual equivalent of a certain change taking place among artists and critics of the period regarding the relative importance of the creative act. In an earlier time, the artist had been considered merely the fabricator of the finished product: the painting, not the artist, was of primary importance. But with the Namuth films, people could see, for the first time, the physical enactment of "action painting." Some art historians argue that the mythology which arose around Jackson Pollock following his death is based largely on this rare film footage. According to the art critic Barbara Rose, "in many respects, the conversion of reality into myth, the essence of media culture, began with Namuth's documentation of Pollock painting."

The Cedar Street Tavern:
Booze, Broads, and Abstract Expressionism

With his return to drinking, Pollock also began spending more time away from his studio, usually in bars. In East Hampton, he would go to a local bar by the railroad station. But in New York, he frequented

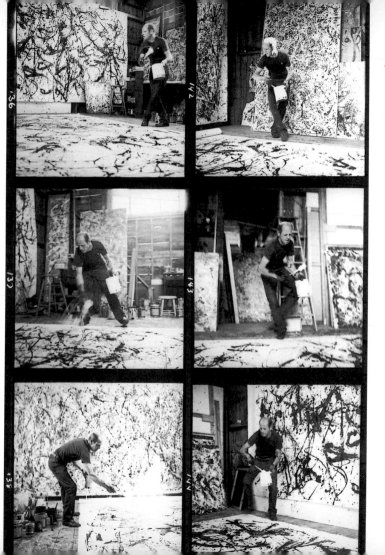

Jackson Pollock
1950

Photograph by Hans Namuth
Collection Center for Creative
Photography, The University of
Arizona. ©1991 Hans Namuth Estate

the Cedar Street Tavern, a favorite artists' hangout on University Place in Greenwich Village. (It was at a different location from today's Cedar Tavern, also on University Place.)

Within the Greenwich Village art world, the Cedar Street Tavern (known among "hip" artists simply as "The Bar" or "The Cedar Bar") was the "in" place for painters to meet and socialize, and it remained so throughout the 1950s.

The Bar, located between a drug store and a grocery store (handy for one-stop shopping) served as a meeting point and informal community center for artists, many of whom lacked telephones and even mail delivery in their cold-water studios. A bulletin board in the back of the bar listed jobs wanted, lofts to let, and gallery announcements. The owner, John Bodnar, and his bartenders were unusually generous in cashing checks and extending credit to regular patrons and made allowances for the often disruptive antics of the heaviest drinkers in the group, including Jackson Pollock, his buddy, the painter **Franz Kline** (1910–1962), and Pollock's rival, Willem de Kooning.

In its heyday, this plain, smoky room was frequented by working men in the afternoon and artists at night. As Abstract Expressionism became more famous, the bar became popular with a mixed crowd, and by the early 1960s it was overrun by tourists.

A Great art-world Rivalry: Pollock vs. de Kooning

While Pollock may have been paralyzed by the self-consciousness that comes with fame, he was also obsessed with a need to be recognized as the world's greatest living artist. His main competition for this honor (aside from Picasso, far away in Europe) was the abstract painter Willem de Kooning, who lived in New York City.

During the late 1940s and early 1950s, the "rivalry" between Pollock and de Kooning split the art world neatly in two. Critics, painters, and collectors all had strong opinions on the subject of which man was the better artist. Among the critics, Greenberg backed Pollock, while Rosenberg joined Tom Hess, editor of *ARTnews*, in supporting "Bill" de Kooning. Argument on the subject of Pollock and de Kooning animated many an evening conversation (or brawl!) at the Cedar Street Tavern.

Since both artists were "action painters," the argument about who was the greater artist essentially boiled down to the issue of diligence and technique (de Kooning) versus risk-taking and inspiration (Pollock). De Kooning, who came from Europe and had been classically schooled, offered a more refined and "finished" technique (though it is hard to see any polish to his technique in his early paintings). Despite heavy drinking, de Kooning worked to a consistent standard; he was also affable and encouraging to younger artists. Pollock, on the other hand, was wild and unsociable, said his great inspiration was nature, and was much

more likely to punch a young painter than to say something nice to him (or her). While perhaps more innovative, by the early 1950s Pollock's production had slowed to a trickle—all of which made comparisons to de Kooning particularly irksome to him.

The conflict between Pollock and de Kooning may seem like that of two bullies in a schoolyard, and in many ways it was. But, whatever their attitudes toward each other, they admired each other's work. The rivalry between them was really more the result of conflicting opinions held throughout the art world, and, to some extent, to the idle gossip that inevitably exists within any ambitious, competitive, and tight-knit group.

Help from a fellow artist: Alfonso Ossorio

Pollock relied heavily on his friends for financial support, and during the most critical years of his career, the friend he relied upon most was fellow artist **Alfonso Ossorio** (1916–1990). Ossorio, a wealthy Surrealist painter and sculptor who lived on a large estate in East Hampton, was the only person to buy a painting from Pollock's 1950 show at Betty Parsons. By the time Ossorio bought Number 1, 1950,

> **FYI:** Ossorio eventually received $2 million for *Lavender Mist* when he sold it to the National Gallery in Washington, D.C. in 1976, despite claims by art experts that the aluminum gloss paint used by Pollock had dulled over time and ruined the painting.

OPPOSITE
White Light. 1954
Oil, enamel, and aluminum paint on canvas
48 ¼ x 38 ¼"
(122.4 x 96.9 cm)

The Museum of Modern Art
New York. The Sidney and
Harriet Janis Collection
Photograph © 1998 The Museum
of Modern Art, New York

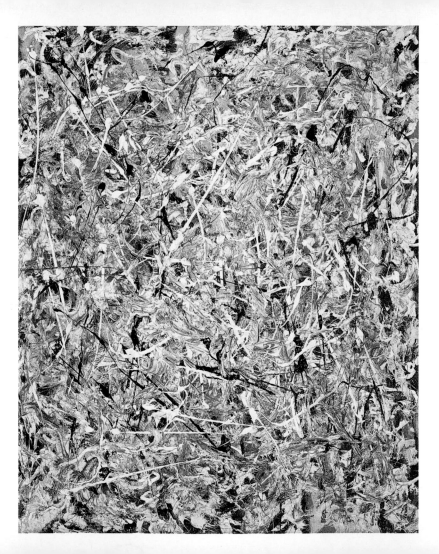

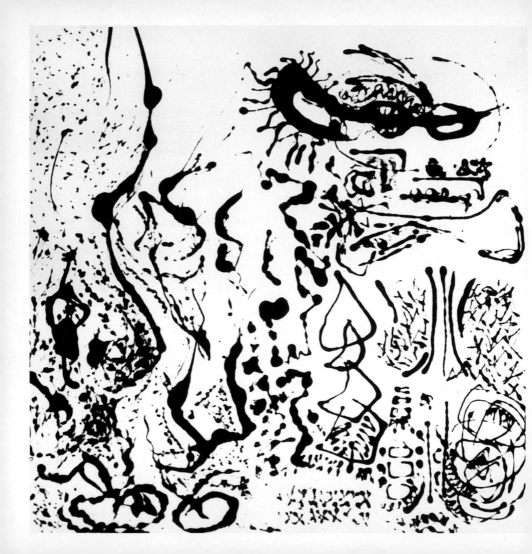

later known as *Lavender Mist* (a title given to the painting, incidentally, by Greenberg), he was already good friends with both Pollock and Krasner and had been helping them out financially for some time. Ossorio and his life partner, Ted Dragon, believed deeply in Pollock's talent. After the 1950 show, Ossorio helped arrange an exhibition for Pollock in Paris. The exhibition took place at Studio Paul Facchetti on March 7, 1952, with Ossorio paying for the publication of a catalogue.

OPPOSITE
Number 5, 1951:
"Elegant Lady"
1951. 58 x 55 ½"
(147.3 x 140.9 cm)

Pollock and Money

Though Pollock created some of the most highly valued works of 20th-century art, he lived most of his life in poverty. Despite his visibility, neither Peggy Guggenheim nor Betty Parsons made money from the sale of his work. By the end of his life, Pollock was noticeably bitter that his critical success had never translated into wealth, or even financial stability.

Five specific examples:

- During the period in which he showed with the Betty Parsons Gallery (1948–1952), Pollock and Krasner relied on handouts from wealthy friends to pay their bills.

- In 1948, while in deep financial trouble, Pollock was made the recipient of the income of a small trust fund—$1,500 paid in quarterly installments—which was earmarked for the advancement of

art and archaeology. The grant was secured with the help of critic James Johnson Sweeney, who had met Pollock through Peggy Guggenheim.

OPPOSITE
Number 7, 1951
1951. 56 ½ x 66"
(1.435 x 1.676 m)
framed:
57 ¾ x 67 ⅜"
(1.467 x 1.711 m)

- Pollock was careful to re-use his materials whenever possible to save money. If a painting did not succeed, he would scrape the paint from the canvas and start over again.

- In 1954, though Pollock was the most celebrated artist of his generation, he contemplated moving out of his home in The Springs to live free on the Ossorio estate.

- Pollock never owned a new car. After cracking up his second-hand Cadillac in 1955, Pollock traded two works of art with the gallery owner Martha Jackson for a used green Oldsmobile convertible coupe—the car in which he ultimately died.

Life after The Drip: Pollock's New "Poured" Technique gets Mixed Reviews

Depressed, self-conscious, and struggling to reconcile himself to his lack of financial success, Pollock soon began to feel that his Drip paintings had led him to a **creative dead end.** Rather than continue to create the same sort of painting over and over again, Pollock returned to the mythic imagery that had interested him in earlier years. Soon **eyes, totems, and both human and animal figures** began to

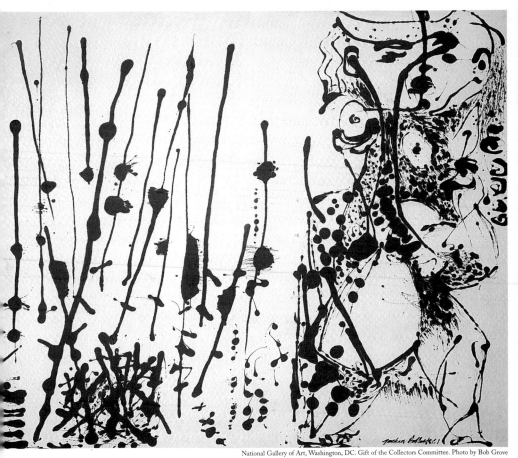

National Gallery of Art, Washington, DC. Gift of the Collectors Committee. Photo by Bob Grove

reappear in his paintings. Many reviewers were skeptical of the new work. Clement Greenberg, however, remained supportive, noting that "recognizable images appear—figures, faces, fragments of a wolflike anatomy reminiscent of things seen in Pollock's pre-1947 art." Just why he chose to return to imagery, no one knew. "I can't say why," Lee Krasner later told an interviewer. "I wonder if [Jackson] could have."

Pollock carried over many of the techniques he had developed in his Drip works to create these new paintings. **The Poured works** were done with black (or, occasionally, brown) paint on large strips of unprimed canvas. As with the Drip paintings, Pollock laid the canvas on the floor of his studio and painted, using his highly physical, dance-like manner. This time, however, he used sticks, brushes, and a new implement—a paint-filled **turkey baster** (which Krasner later likened to "a giant fountain pen")—to create the impression of "poured" paint. Unlike the large-scale Drip works, however, Pollock created a whole series of Poured works on one large piece of canvas, cutting the fabric apart afterward to create the individual works.

These works became known variously as **Poured Black Paintings,** the **Black Paintings,** or the **Black-and-White Paintings.** Made at a time when Pollock was drinking and depressed, the works are filled with dark, violent, psychologically troubled imagery, much of it recalling Pollock's Orozco-inspired drawings and paintings from more than a decade earlier. Yet they also feature an elegant fluidity. These often

frightening pictures are, in technical terms, Pollock at the top of his form, for they demonstrate his complete mastery of the Drip and Pour techniques in creating intricate and beautifully composed representational drawings.

Four Interesting and Slightly Silly Facts about the Black-and-White Paintings

- Black-and-white works were popular among other leading artists at the time that Pollock did his Black-and-White paintings. Franz Kline, Robert Motherwell, and Willem de Kooning all did black-and-white work during this period.

- Some critics have suggested that Pollock's adoption of a mono-chrome palette was a response to Picasso's *Guernica,* completed more than a decade earlier. Confronted with this question, Lee Krasner replied, "If so, it's an awfully slow burn." (Translation: Not even Jackson Pollock would have waited so long to respond to Picasso's use of black-and-white imagery.)

- There is no white paint in the so-called Black-and-White Paintings. The "white" is the color of the unprimed cotton canvas. (In this way, Pollock was unlike his good buddy Franz Kline, who used lots of white paint in his black-and-white abstractions.)

- With the Black-and-White paintings, Jackson Pollock is one of the few artists in history ever to have created great art using a turkey baster!

Experimenting, at the same time, with Works on Paper

Another body of work completed by Pollock during this period is a series of drawings that are similar to the Poured Black Paintings. Instead of using cotton canvases, however, Pollock worked in a smaller format, experimenting with two different kinds of paper: a thick rice paper and a heavy, handmade paper fabricated by a Long Island paper-maker named Douglass Howell. Pollock enjoyed the way these papers interacted with his poured and spattered ink, and the way in which spots and marks from one drawing would bleed through to the next

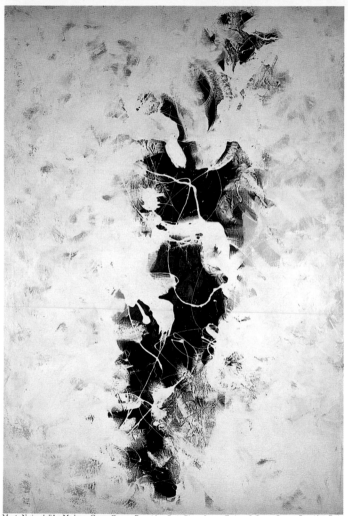

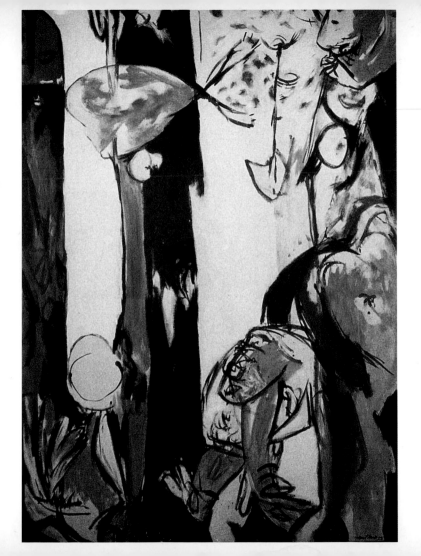

sheet of paper, creating the beginning of a new drawing. Today they are counted among the finest of his late works.

Gallery Blues: Leaving Betty Parsons for Sidney Janis

In mid-1952, when his contract with Betty Parsons ran out, Pollock decided to leave his dealer. Parsons had been a great supporter of Pollock's work, but she had had little success in making sales on his behalf, in large part because the work remained controversial. Despite the notoriety and public recognition created by the Cecil Beaton photo shoot in 1951, only one painting from the show had sold (to Pollock's friend Ossorio). Worse, in Pollock's last show with Parsons in 1952, not only did no large work sell, but also one work (Number 7, 1951) was **vandalized** in the gallery.

Through the years, many people have felt that Pollock and his friends did Betty Parsons a disservice by leaving her just as their work became saleable. Historically, the sad truth is that many women gallery-owners have not profited as much as men have in the sale of art, although today there are a number of powerful women art dealers. Parsons herself said it best: "When I started my gallery, nearly all art dealers were women.... I think women are more creatively oriented than the male dealers, who are all money, money, money. That's the first male consideration."

OPPOSITE
Easter and the Totem. 1953
84 ¼ x 58"
(214 x 147 cm)

The Museum of Modern Art
New York. The Sidney and
Harriet Janis Collection
Photograph © 1998 The
Museum of Modern Art
New York

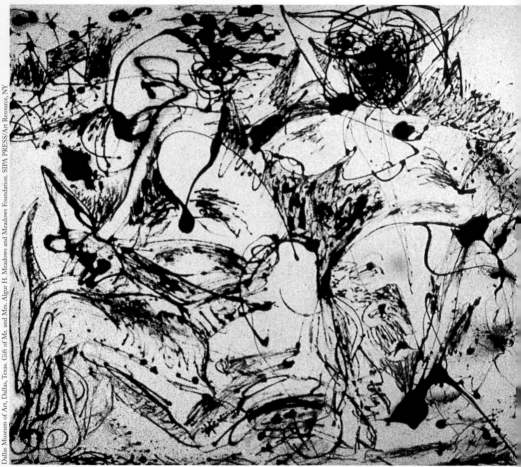

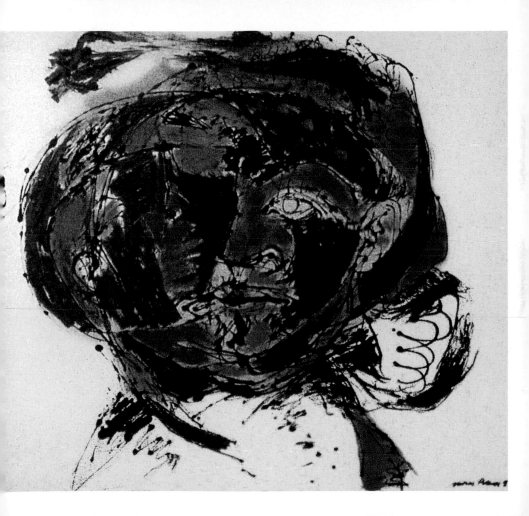

PREVIOUS PAGE
Portrait and a Dream. 1953
Enamel on canvas
4' 10 ⅛" x 11' 2 ½"
(1.48 x 3.42 m)

Pollock's new dealer, **Sidney Janis** (1896–1989), had a gallery space just across the hall from Betty Parsons. Janis had more capital and was able to guarantee sales for his artists. As a result, Pollock was just one of several top artists, including Mark Rothko and Barnett Newman, who left Parsons for Janis at roughly the same time.

Sidney Janis was a well-known collector and author on abstract and Surrealist art when he opened his gallery in September 1948. He and his wife had been collecting art since 1926.

Janis first met Pollock in 1942, when Lee Krasner brought him to Pollock's West 8th Street studio—a visit that left him deeply impressed. A few months later, Janis decided to include an illustration of Pollock's *The She-Wolf* (1943) in his book, *They Taught Themselves: Abstract and Surrealist Art.*

As Janis later recalled, "Pollock never enjoyed the sweet smell of success. $8,000 was to stand as the greatest amount we received for a Pollock during his lifetime…. We sold *Blue Poles,* a somewhat smaller picture, for $6,000."

While Pollock was showing with Janis, he finally began to make money from the sale of his work. In part, Janis's success at selling was due to timing. He held a Pollock exhibition in November 1952, at roughly the same time that a representative sampling of Pollock's best work was included in an important exhibition entitled **"15 Americans"** at The Museum of Modern Art. And then, of course, there was the cumulative effect of Pollock's previous publicity.

Despite his creative uncertainty, Pollock managed to put together another exhibition with Janis in February 1954. Pollock's final exhibition, after several years of artistic inactivity fueled by alcoholism and depression, would be a **retrospective** at the Sidney Janis gallery in December 1955.

A Final Return to Color, with Mixed Results

Pollock's last two undisputed masterpieces, created during a time of prolonged mental and emotional crisis, were a surprise. Color returned. *Blue Poles* (1952) and *Portrait and a Dream* (1953) were created during a brief period when Pollock felt capable of painting on a large scale. In *Portrait and a Dream,* Pollock featured a close-up self- portrait on the left-hand side of the canvas, and an abstracted erotic encounter on the right. Scholars have suggested that in this work, Pollock is attempting to describe his increasingly troubled relationship with his wife. Other significant color works from this period include

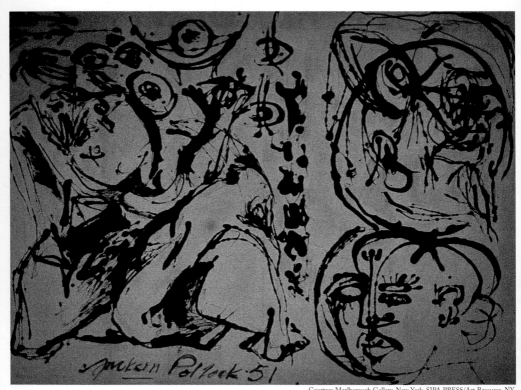

The Deep and *Easter and the Totem.* The paintings of 1953–55 are characterized by a return to brush and palette knife after Pollock's prolonged experiments with the Drip and Pour techniques.

Deepening Depression leads to Estrangement from Krasner, Old Friends, and Supporters

During the last years of his life, Pollock was profoundly depressed. He drank heavily, became bloated, and had many other health problems. He suffered from extreme lethargy and sexual impotence as well as creative paralysis.

Many friends recall that he cried constantly. Some, like the artist Larry Rivers, grew disgusted with his lack of self-control and turned against him. As Rivers remembered, "What was obviously gorgeous in his work was becoming infused with a mindlessness impossible to separate from his social personality."

Italo Tomassoni, the Italian writer and critic, later recalled that "the act of painting was like a religious ritual which held him in a state of lucid delirium…. He had become completely dependent upon alcohol, and lived on the brink of imminent catastrophe."

His relationship with his wife began to disintegrate. During his alcoholic binges, Pollock was combative and abusive to Krasner. While out drinking, Pollock met and slept with other women. He even attacked

Krasner in his painting, caricaturing her large nose and fleshy lips in one of his black Poured paintings, *Number 27, 1951.*

A Brief "Love Affair"

In February 1956, Pollock met a pretty young brunette at the Cedar Street Tavern, an artist's model from Newark, New Jersey, named **Ruth Kligman.** Despite his reputed sexual impotence, the two began an affair. As he told his neighbor, Jeffrey Potter, "I've gone dead inside, like one of your diesels on a cold morning. I need a booster…a sex-starter, so my sap will flow."

Krasner, confronted with Pollock's infatuation, decided to spend time on her own. She departed on a six-week trip to Europe.

While she was away, Pollock invited Kligman to stay with him, on and off, at the house in The Springs. Kligman later recalled that "Jackson didn't work. Every day was similar to the next, talking about getting started and never getting to it. His conflict consumed his energy…. At times when he was very sad he would cry and say, 'It wasn't worth it, it wasn't worth the pain and the sacrifice, it's asking too much; I can't give that much any more, I'm too miserable, and they never get the point anyway.'"

A History of Drinking and Driving

Pollock was well known among the East Hampton police for his drunk driving. In fact, he had been involved in several accidents in East Hampton before the one that killed him. On December 29, 1952, Pollock had crashed his 1947 Cadillac convertible and totaled it. In August 1954, Pollock was drinking with his artist friend Franz Kline when Kline crashed his car. And police recalled that Pollock was sometimes too drunk even to find his car. The East Hampton police would give him a lift home in a squad car.

FYI: Ruth Kligman survived Pollock's fatal car crash but was never able to collect the painting she once claimed Pollock had promised her—Krasner had inherited nearly all of her husband's estate and she had no intention of giving her husband's girlfriend a painting. Kligman later sued the Pollock estate for negligence, asking for $100,000, But in the settlement, Kligman received only $10,000, much of which went to pay her medical expenses. (Edith Metzger's family also received $10,000.) Dubbed **"The Death Car Girl"** by poet Frank O'Hara, Kligman went on to have romantic involvements with Pollock's fellow artists Franz Kline and Willem de Kooning. Years afterward, she published an account of her seven weeks with Pollock in a book entitled *Love Affair.*

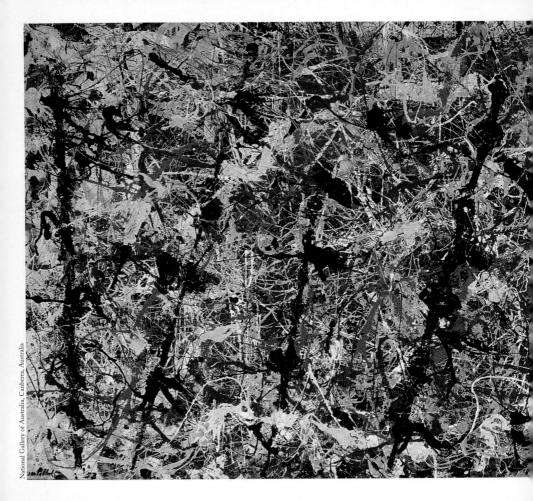

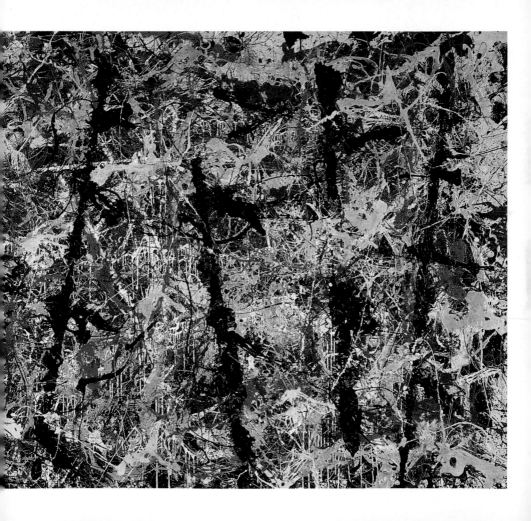

The End: Two Tragic Deaths

After attending a concert at Ossorio's house on the evening of August 11, 1956, Pollock was returning home with Ruth Kligman and Kligman's girlfriend, a beautician named Edith Metzger, who had accompanied Kligman to Pollock's house for the weekend. Pollock, drunk, lost control of his Oldsmobile convertible on a curve. The car plowed through 175 feet of underbrush, flipped end-over-end, and landed upside-down. Metzger was killed in the crash; Kligman suffered back injuries and a shattered pelvis. Pollock, thrown from the car, cracked his skull against an oak tree and died instantly.

A Hero's Burial

While the art world was stunned by the tragedy, many artists, critics, and friends were appalled that Pollock had also caused the death of innocent Edith Metzger. When asked by Krasner to speak at Pollock's funeral, critic Clement Greenberg declined to do so out of sympathy for Metzger, saying "I want nothing to do with it." Four days after his death, on August 15, 1956, Pollock was buried at a small nearby cemetery, the Green River Cemetery, on Accobonac Road. The funeral was well attended. Both Lee Krasner and Stella May Pollock, his mother, were present. Today, Pollock's grave at Green River Cemetery is marked by a boulder inscribed with a replica of his signature as well as his life dates, 1912–1956.

Sound Byte:

"When they started out, the 'abstract expressionists' had the traditional diffidence of American artists. They were very much aware of the provincial fate lurking all around them. This country had not yet made a single contribution to the mainstream of painting or sculpture. What united the 'abstract expressionists' more than anything else was their resolve to break out of this situation. Whatever else may remain doubtful, the 'centrality,' the resonance, of the work of these artists is assured."

—CLEMENT GREENBERG, art critic

Pollock's Legacy: New Interest in Abstract Expressionism

Pollock's death, and the myth surrounding it, led almost immediately to greater interest not just in Pollock, but in all of contemporary painting. Accounts of Pollock's death, along with the story of his career, were widely published in American and European papers. The romance of the story quickly captured the public imagination.

Within the art world, interest grew as well: Less than six months after his death, a Pollock retrospective exhibition was mounted at The Museum of Modern Art in New York. Exhibitions of Pollock continue to this day, and no survey of American painting since 1945 is credible without discussion of this great artist.

Looking back, artist Robert Motherwell has described Pollock's story as "a permanent legend equivalent to the Van Gogh one." But, quite apart from his troubled and violent life, Pollock remains an inspiration to artists, critics, and the art-viewing public. For his work is among the most profound and deeply satisfying of visual experiences. Writers, critics, and artists agree that Pollock best embodies the spirit of a restless, questioning age.

Pollock's accomplishments as an artist were exceptional. During the course of his brief, troubled life, Pollock had passed through the provincial, regionalist art of 1930s America, absorbed the essence of a number of world art movements such as primitivism, muralism, and Surrealism, and quickly developed a painterly vocabulary and artistic technique that were entirely his own. In creating a distinctive identity for American postwar art, he endured poverty, loneliness, ridicule, and immense psychic anguish. In the end, his only reward for his hard work had been the work itself.

DATE DUE

AUG 15 2013		

GAYLORD #3522PI Printed in USA